LIVERPOOL
GHOST
SIGNS

T0347157

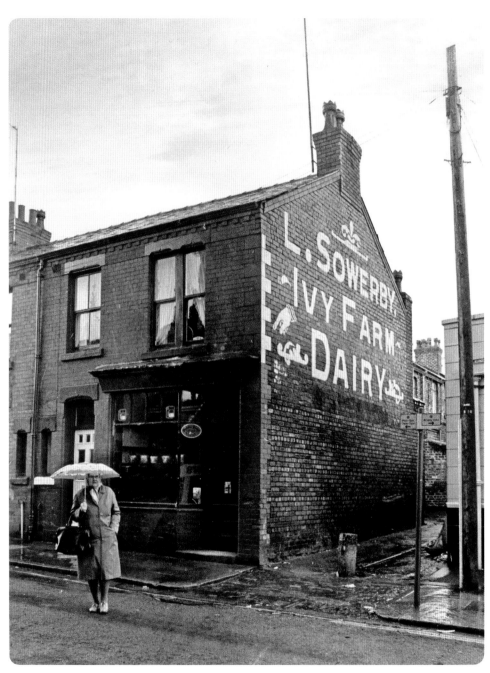

An exquisite photograph of an advert for Letitia Sowerby's dairy at 2 Fernleigh Road, L13. Letitia was here during the 1930s through to the 1950s and was from a family of dairymen. Mrs Mary McLeod was at this address beforehand, also running a dairy. It is interesting to note a manicule (the pointing hand) which is a rare sight today, but during the 1930s and '40s was zeitgeist.

CAROLINE AND PHIL
BUNFORD

LIVERPOOL
GHOST
SIGNS

A SIDEWAYS LOOK
AT THE CITY'S
ADVERTISING
HISTORY

The
History
Press

First published 2012

The History Press
The Mill, Brimscombe Port
Stroud, Gloucestershire, GL5 2QG
www.thehistorypress.co.uk

© Caroline and Phil Bunford, 2012

The right of Caroline and Phil Bunford to be identified as
the Authors of this work has been asserted in accordance with
the Copyrights, Designs and Patents Act 1988.

All rights reserved. No part of this book may be reprinted
or reproduced or utilised in any form or by any electronic,
mechanical or other means, now known or hereafter invented,
including photocopying and recording, or in any information
storage or retrieval system, without the permission in writing
from the Publishers.
British Library Cataloguing in Publication Data.
A catalogue record for this book is available from the British Library.

ISBN 978 0 7524 6570 8

Typesetting and origination by The History Press
Printed in India.

CONTENTS

ACKNOWLEDGEMENTS

We would sincerely like to thank Tony Lewery for the kind permission to use his two photographs of Sowerby Dairy and Hornby Lowe's Cutlery Stores and for having the foresight to take such wonderful photographs; Andrew and the staff at Crosby Library Local History Department, for their help and friendly service; Mark Russell, for help and support; Duncan Scott, for additional information and for the kind permission to use the image of Harper's Dairy bag; Ms Joan Fenney; Ged Fagan; PhD Design; Philip G. Mayer; Sam Roberts at the Ghost Signs project, for initial inspiration and for writing a wonderful foreword; HAT archive; Bob Pearson of Burton Bell & Co.; Matilda Richards at The History Press, for her friendly advice and encouragement; Susan J. Williams, for the information on Buchanan & Co.; Denis Torpey; Dave and Julie Karellen; Mark Woolfenden at Afonwen; and, last but by no means least, our families for their never-ending support.

If you have any further information on any of the signs or brands featured in this book, we would love to hear from you. Please contact us at Ghostsigns@hotmail.co.uk

FOREWORD

History is all around us, not just hidden in dusty libraries and archives. The streets are alive with stories from the past, if we only take the time to stop, look and listen. Many of these stories begin with old signs speaking to us, uttering product names and slogans from years gone by. They no longer serve any practical purpose, but their story is one of survival against the elements and the efforts of property developers to erase their memory from history.

'Ghost signs' is a term that has come to describe these historical specimens that whisper suggestions of which brand of soap to buy, or where to find the best deals on tobacco. Often faded or fragmented, these signs are a common feature of towns and cities across the country. They reveal insights into our commercial past and the rise (and sometimes fall) of myriad products and businesses. Liverpool is no exception and the following pages commit some of these stories to print, ensuring their survival beyond the already extended lifespan of the ghost signs that tell them.

Sam Roberts, 2012
www.ghostsigns.co.uk

Sam Roberts has written numerous articles on historical hand-painted advertising and, in 2010, curated the History of Advertising Trust Ghostsigns Archive.

ONE

SOUTH LIVERPOOL

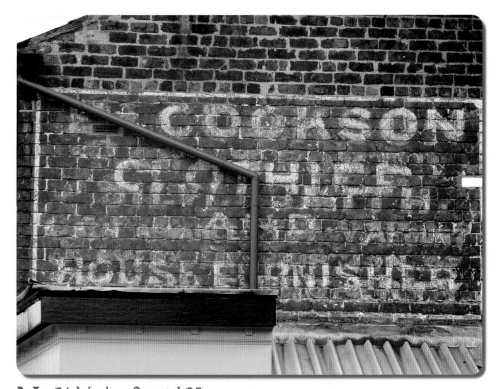

No. 36 Woolton Street, L25
This sign advertised the business of the Cookson family from the 1880s until the late 1970s. They were pawnbrokers predominantly but also jewellers, clothiers and house furnishers at varying times.

No. 8 Woolton Street, L25

This was the premises of T. Lawton & Sons, who were hardware dealers from the Victorian period until at least the 1970s.

No. 58 Allerton Road, L25

This building has seen many trades over the years. The street directory for 1900 lists a boot and shoe repairer, whilst in 1913 a butcher sold his wares here. This advert for 'antiseptic shaving cream' refers to the various hairdressers that inhabited the building from at least 1918 until the late 1940s, when the Co-Op moved in.

No. 263 Woolton Road, L16

George Henry Radforth is listed at these premises from at least the early 1930s until the late '50s plying his trade as a butcher. This wonderful sign is quite unique in Liverpool and still looks as fresh as the day it was made. This shop is now a café.

Broadgreen Road, L13

From at least 1955 until 1970 the street directory lists Bendix – a self-service launderette. There also seems to be another layer of signage beneath this one that advertises 'Hovis', but is difficult to read. This is now a Liver Launderette, which is a prevalent chain across Merseyside. They opened their first branch in 1951 and are now the largest operator of launderettes in the UK.

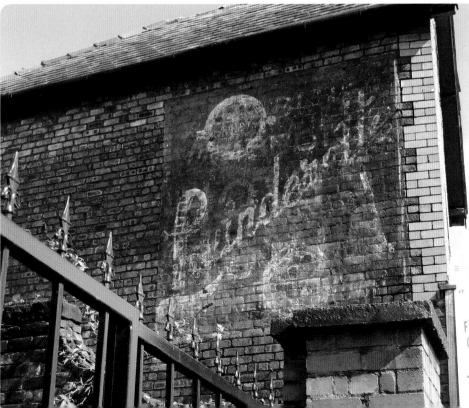

FISH &
CHIPS

Rose Lane / Rose Brae, L18

Harper's Dairy was situated on Rose Lane and listed in the trade directory from the late 1930s. It continued as a business until 2000.

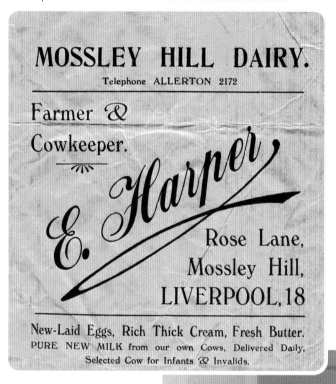

MOSSLEY HILL DAIRY.

Telephone ALLERTON 2172

Farmer & Cowkeeper.

E. Harper

Rose Lane,
Mossley Hill,
LIVERPOOL, 18

New-Laid Eggs, Rich Thick Cream, Fresh Butter.
PURE NEW MILK from our own Cows, Delivered Daily.
Selected Cow for Infants & Invalids.

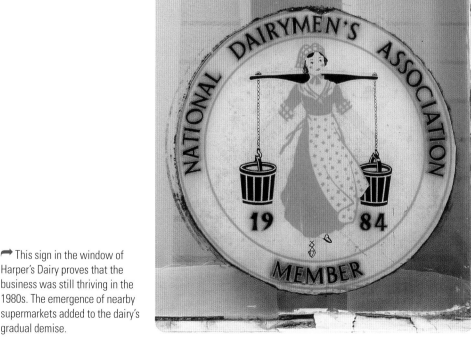

➡ This sign in the window of Harper's Dairy proves that the business was still thriving in the 1980s. The emergence of nearby supermarkets added to the dairy's gradual demise.

t No. 35 St Mary's Road, L19

Cousin's confectioners were once a common sight throughout the city. The business was started by Ernest and Eric Gibson, who opened their first shop on Aigburth Road in 1946. They had a branch on most high streets across Liverpool.

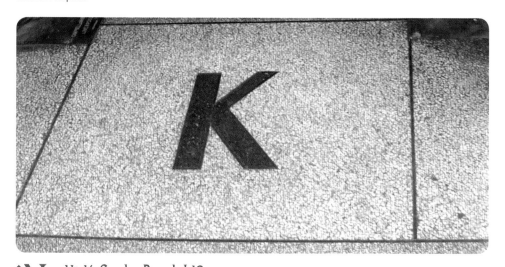

t Nos 14-16 Speke Road, L19

This 'K' stands for Kearns, and this was once the butcher's shop of William Edward Kearns who had a chain of stores throughout Liverpool. This step can still be found at his former shop in Garston. It is now a discount store.

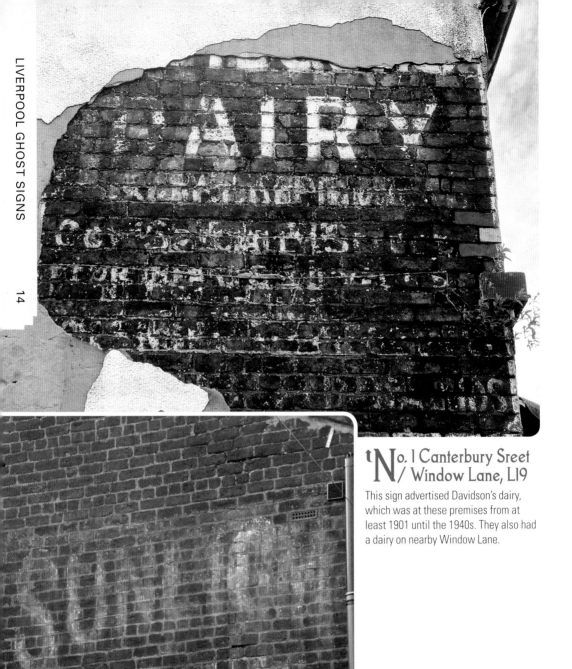

↑No. 1 Canterbury Sreet / Window Lane, L19

This sign advertised Davidson's dairy, which was at these premises from at least 1901 until the 1940s. They also had a dairy on nearby Window Lane.

←No. 33 Argyle Road, L19

From at least the 1890s this building acted as a grocers/bakers. This wonderful Sunlight Soap advert must have been seen on grocers' stores throughout the country and it is lovely to find one so tucked away as this, down a quiet residential street.

No. 95 St Mary's Road, L19

This well-weathered sign once advertised the funeral directors W.J. Rimmer, who were listed at these premises from at least 1931. Prior to this, they were resident at No. 83 and also No. 81 St Mary's Road. It is interesting to note that they conducted the funeral of Arthur Lawrence, who was a steward upon the *Titanic*.

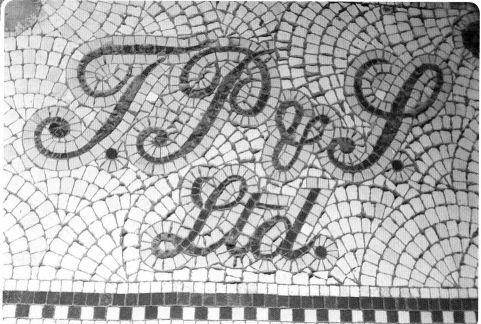

No. 142 St Mary's Road, L19

Thomas Porter are an undertakers firm established in 1860, also having offices in Toxteth and Woolton. This mosaic step stood at the entrance to the company's Garston branch for many years. Unfortunately, this step has now been replaced by a new vestibule.

No. 272 Aigburth Road, L17

The former milliner's shop of J. Akrigg & Son. Akrigg is listed in the street directory from the 1890s until at least 1909. This beautiful gilt-lettered sign was uncovered while the shop was being refurbished in 2010.

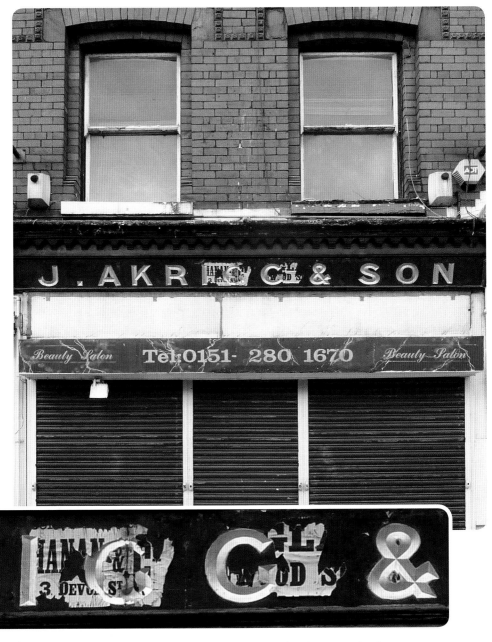

↑ On closer inspection of the Akrigg sign, it is interesting to see there is a paper advertisement on top of the gilt lettering, advertising the firm of Buchanan & Co. of No.3 Devon Street. Buchanan & Co. started off as glass embossers and then moved on to handwritten signs. When the founder, David Buchanan, died, the business was bought out by the Gilson family, and is still in their hands today under the name of Corporate Advertising.

ʄNos 1-3 Kildonan Road, L17

This building began life as a Fire, Police and Escape Station and was listed as such until 1931. In 1934, the building was taken over by Burton Bell and became a builders' merchants. The ghost sign was repainted by the current owner in around 1991, who kept the name of Burton Bell & Co. Unfortunately, the business has now closed down and, at the time of writing, the future of this wonderful sign is uncertain.

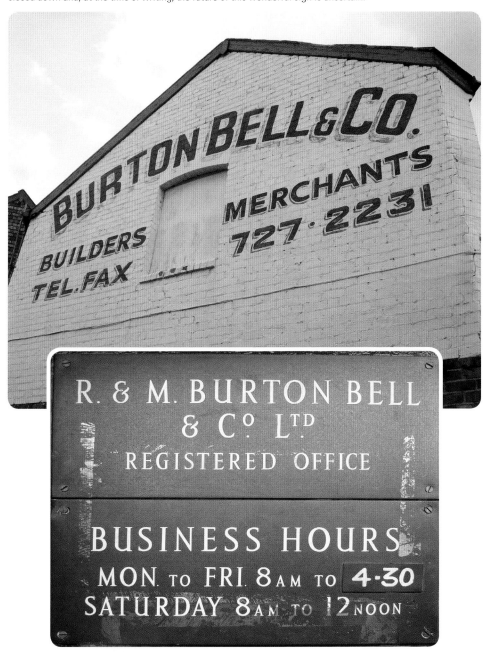

↑ Although this sign is not as old as the painted sign, it is still a lovely example of typography.

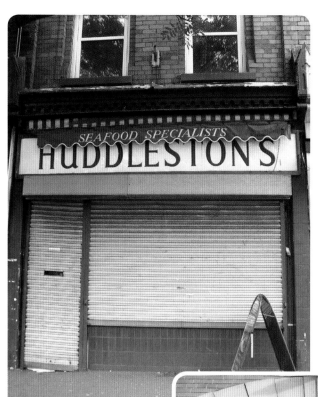

No.317 Aigburth Road, L17

This shop was a fishmonger as early as 1911. Huddleston's are listed on Aigburth Road from at the least the 1930s, when they were at Nos 666 and 68 at varying times. Henry Wilson Huddleston is listed at No. 317 from the early 1950s, and the firm only closed their doors in recent years. This is now a traditional sweetshop.

No.301 Aigburth Road, L17

The Bank of Liverpool was founded in 1831. The Bank eventually acquired Martin's bank in 1918 and became known as Bank of Liverpool and Martins Ltd, yet, by 1928, was shortened to just 'Martin's Bank'. In 1969, Barclays acquired all 700 branches. The wonderful lettering on these window frames could possibly date to pre-1918, when the bank still held its original name.

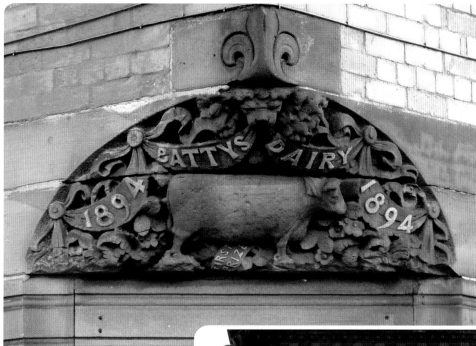

t **A** igburth Road / **A** Brentwood Avenue, L17

This stone carving is on the former dairy premises of Richard Batty & Sons at Nos 85-87 Aigburth Road. The firm were located here from the building's inception in 1894 until the early 1930s, when they moved to Smithdown Road.

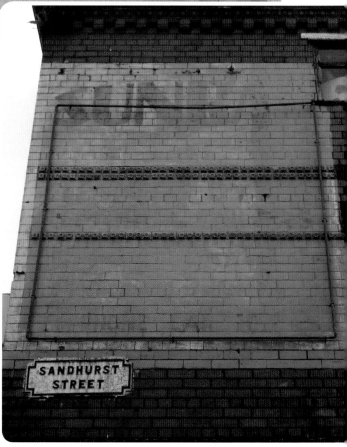

→ **A** igburth Road / **A** Sandhurst Street, L17

This sign promoted the business of Sunray Valet Service (dry cleaners), which had branches at nearby Park Road from 1946. We find the firm listed at this address in Aigburth Road from at least 1950, but by 1960 this branch had closed. By 1972, the business has disappeared from the phone books altogether.

→ Aigburth Road / Alwyn Street, L17

Presumably this Nestlé's sign dates to the early 1900s, when George G. Carrie had a grocery store here. His surname can be seen faintly near the bottom of the sign.

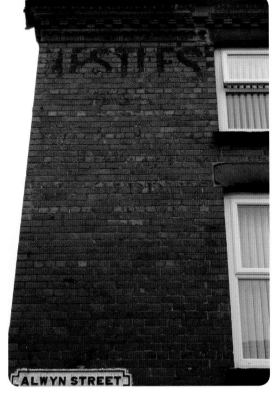

⸲ Aigburth Road / Alwyn Street, L17

On the same wall as the previous picture, this advert was for the *Picture Post* publication that ran from 1938 until 1957, helping to date this sign to between these years.

No. 101 Lark Lane, L17

For many years this building housed Alderson & Co., contractors. In the 1950s until the early '70s, Ranson's watchmakers were here. In recent years it was a delicatessen, but at the time of writing the building is vacant.

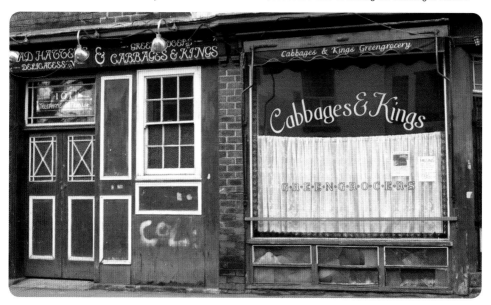

❧ This gilt lettering could possibly date from around 1915, when the firm's telephone number is listed in their directory entry.

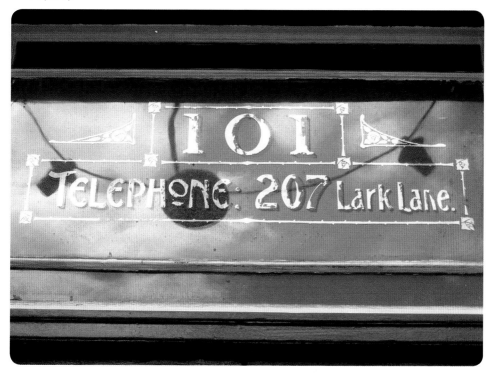

t**B**elvidere Road, L8

Emergency Water Supply (EWS) signs were a common sight during the Second World War, and informed people where their nearest emergency water supply could be found. There are still some surviving examples around the streets of Liverpool, this being a particularly fine sign.

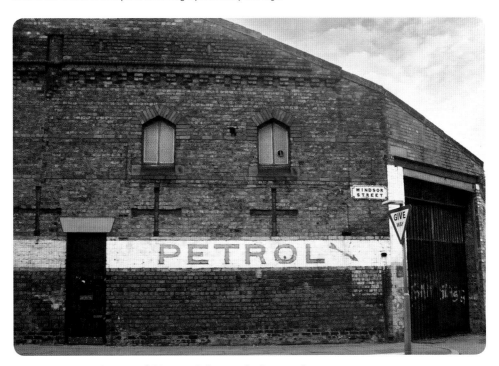

t**W**indsor Street / Upper Warwick Street, L8

This building was an army barracks for the Lancashire 8th Artillery Volunteers in the 1880s. By the early 1920s it had become Atlas Lubricating Co. – oil and grease manufacturers – and went on to become 'Bool Bros', motor engineers in the 1960s. It is still a garage today.

Kelvin Grove / South Street, L8

This ghost sign reads 'Lark Lane 2993 2772' and was to draw attention to the taxi firm of 'Taxilux' (Church & Lythgoe – proprietors), which had premises at 127 South Street from the 1940s through to the 1970s.

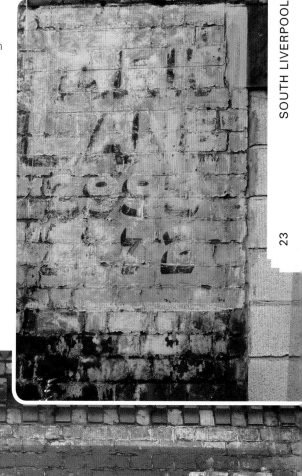

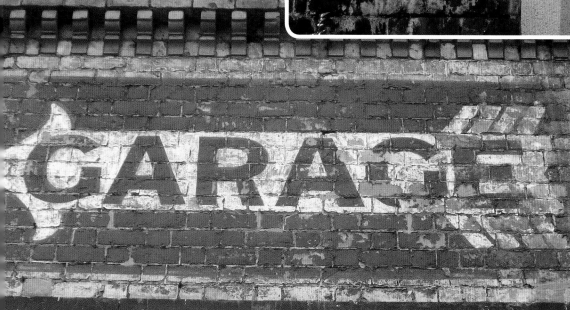

↑ This 'garage' sign advertised 'Villages Garage', which was located at No. 125 South Street from the mid-1920s. It is on the same wall as the Taxilux advert (see above).

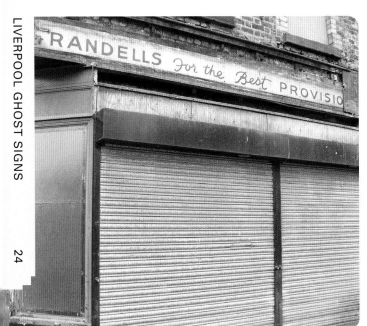

No. 454 Mill Street, L8

Looking at the street directories, Randells belonged to William Randells & Sons. They are listed in the 1945 directory up until 1980, when they disappear from the telephone book after nearly forty years of service to the area. This sign was briefly uncovered during renovation work at the property a few years ago.

Gwendoline Street / Maud Street, L8

This residential house was inhabited by members of the authors' family in the 1960s and '70s. Margaret, John and Daniel Ali all helped to transform the plain paintwork with flowers, psychedelic colours and illustrations. It was covered extensively in local media, and became known in the area as 'The Flower-Power House'. Unfortunately, a new owner has since tried to cover the beautiful designs with drab black paint, but the vibrant colours still manage to shine through.

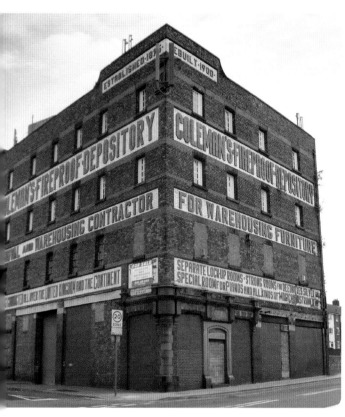

No. 37 Park Road, L8

Edward L. Coleman was listed in the street directory in 1900 at Overton Street and Edge Lane as a furniture remover. By 1905, Coleman's are listed at No. 37 Park Road, as furniture removal and warehousing contractors. Later on, the company is listed as having further premises in Garmoyle Road and Beresford Road. The business was listed up until 1993 in the telephone book and since then the building has been used for phone masts and storage. The structure is a familiar landmark in south Liverpool but is not listed. At the time of writing, the building is currently up for sale.

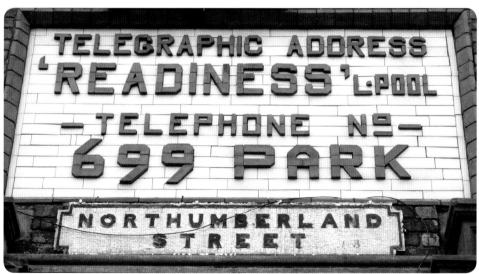

⬆ Here we have a close-up of the 'telegraphic address' for Coleman's and their telephone number – on the Northumberland Street side of the building.

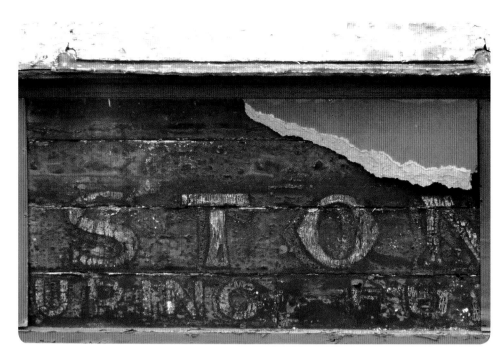

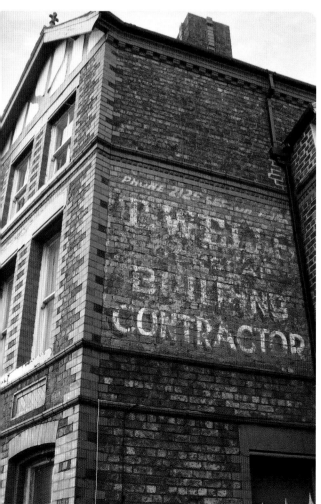

No. 133 Smithdown Road, L7

Lewis Stone's furriers shop (a furrier was a person who prepares or deals in fur) was listed at these premises from the late 1920s until 1936. Before Lewis moved here, this building acted as a Servant's Registry and also a milliner's shop. This sign has only been uncovered in recent years.

No. 463 Smithdown Road, L15

We first find Thomas Wells listed at No. 463 Smithdown Road in the late 1940s, as a builder. By 1959, he has expanded his business and is now listed as a 'General Contractor'. In the 1965 phonebook he has a small advert, but by 1969 Thomas has disappeared from the directory. This building was used as a dairy from at least 1894.

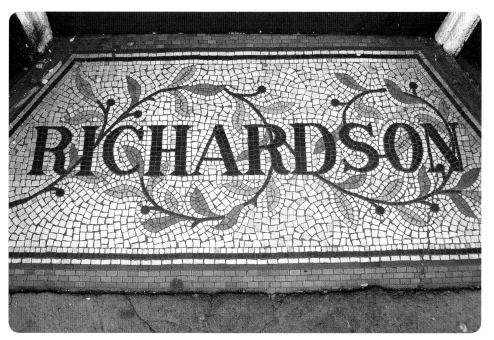

ᵗNo. 214 Smithdown Road, L15

Richard T. Richardson started his chemist business at No. 39 Smithdown Road in the 1880s, but by 1890 he is listed at the premises that boast this fine mosaic step. Richard also had a branch at No. 309 Smithdown Road in the early 1900s. Since 1990, this shop has been a doll and teddy hospital.

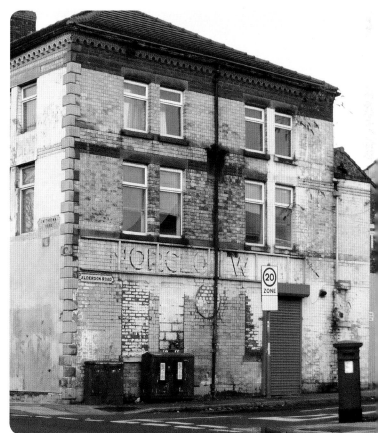

→Nos 187-193 Smithdown Road, L15

This building housed the Salisbury Laundry from at least 1918. By 1964, Golden Grain had taken over the building, producing disinfectants. This was their 'Norclo Works', which presumably refers to one of their products.

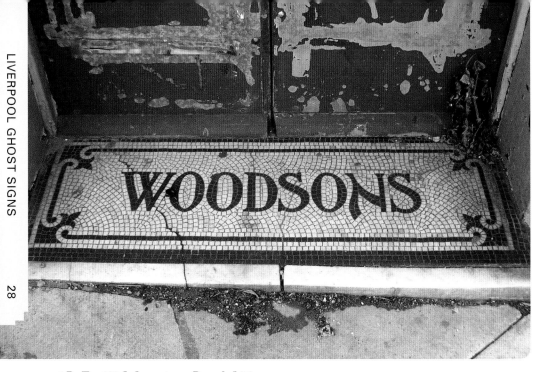

No. 121 Wavertree Road, L15

Woodsons are listed at this address from at least 1908. They had a chain of grocery stores across the city and Wirral, and thrived as a business until at least the 1950s.

Nos 23 & 25 Wavertree Road / Martensen Street, L7

This advert is painted onto the back of John Gordon's former pawnbroker's shop on Wavertree Road. We find Mr Gordon listed at this address from at least 1881. As the years pass, we see him move out of the residential premises above the shop – firstly to Overton Street and then to No. 14 Holly Road in Fairfield, reflecting the success of his business.

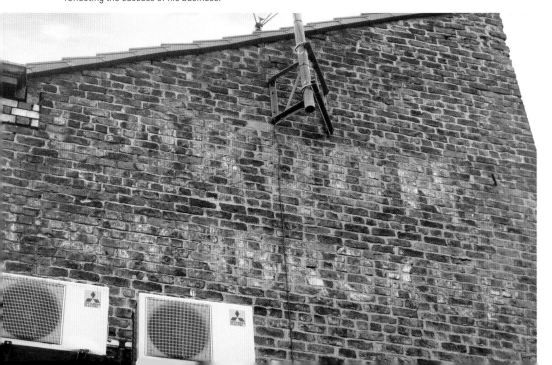

ᵗGladstone Road / Marmaduke Street, L7

This sign is frustrating for lovers of ghost signs. Although the letter 'K' stands out, it is very difficult to decipher the rest of the lettering. In 1938, Thomas Kidd, auctioneer and valuer, lived at this house and, according to his youngest daughter, also had a shop on Great George Street.

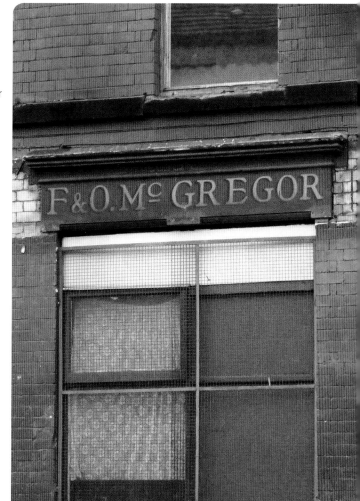

→No. 108 Holt Road, L7

Mrs Florence McGregor ran a newsagency from these premises from at least 1937 until the 1960s. This sign is no longer visible.

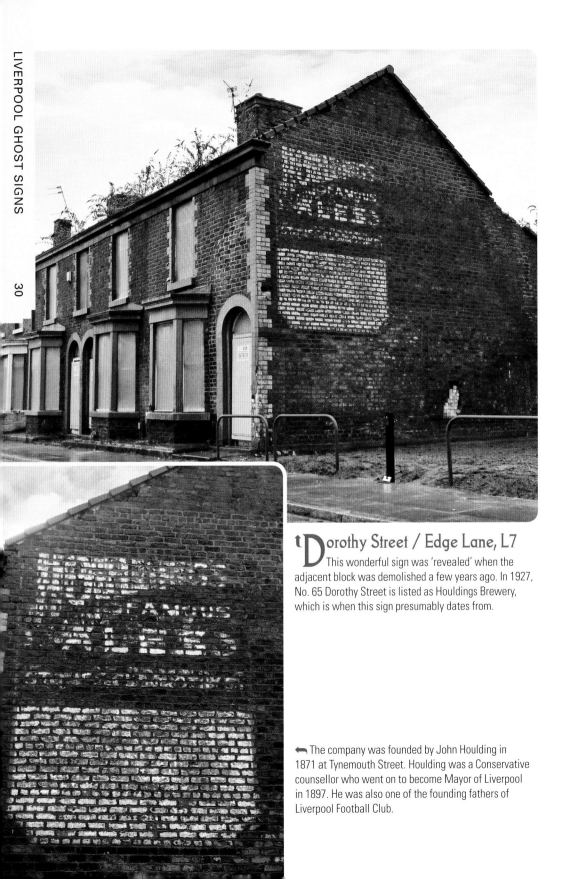

ᵗDorothy Street / Edge Lane, L7

This wonderful sign was 'revealed' when the adjacent block was demolished a few years ago. In 1927, No. 65 Dorothy Street is listed as Houldings Brewery, which is when this sign presumably dates from.

The company was founded by John Houlding in 1871 at Tynemouth Street. Houlding was a Conservative counsellor who went on to become Mayor of Liverpool in 1897. He was also one of the founding fathers of Liverpool Football Club.

No. 15 Edge Lane, L7

The 'Oscar' named on this lovely date stone is not in fact the owner of the building, but appears to be the proprietor's baby son, who was born in 1889. The owner of the premises was Joshua John Lindop, who was a poulterer and fishmonger. He did not stay at this address for long as by 1908 F.H. Jones is listed as a fishmonger here, and stayed until at least 1941.

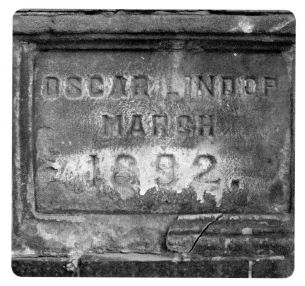

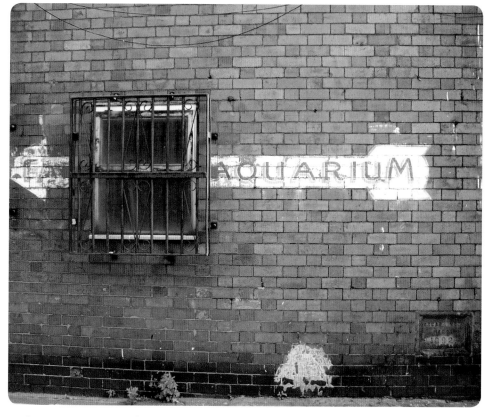

Adelaide Road / Edge Lane, L7

The only letters on this sign that we can decipher (besides Aquarium) are 'FA . . .'. In 1955, Mr Thomas C. Farrall is listed here as a fishmonger. This must somehow link in with the Aquarium sign and assumedly read 'Farrall's Aquarium'. This sign was on the same wall as the Lindop stone. This block has now been demolished.

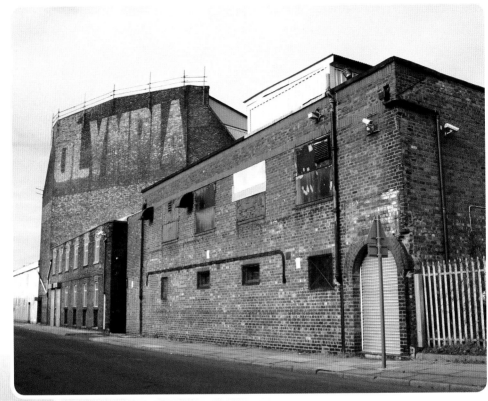

ᵗ**W**est Derby Road / Boaler Street, L7

Built as a theatre in 1905, this is one of only two theatres in the country to be built with a circus arena inside which could also accommodate aquatic displays. By 1925, the building had been converted into a cinema, which closed in 1939. It became the Locarno ballroom after the Second World War, and then a bingo hall. Recent years have seen it become a venue for boxing and live sports.

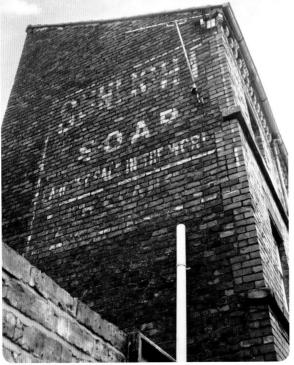

←**G**range Street / Rocky Lane, L6

Originally produced by the Lever Brothers in 1884, Sunlight Soap was designed for washing clothes and general household use. It was one of the earliest internationally marketed branded products, and one of the first examples of a cleaning product being produced as a consumer commodity; prior to Sunlight, clothing was generally washed using home-made soap.

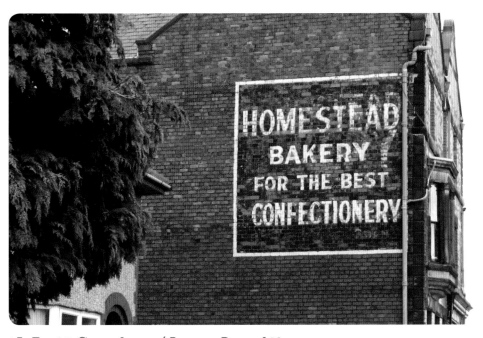

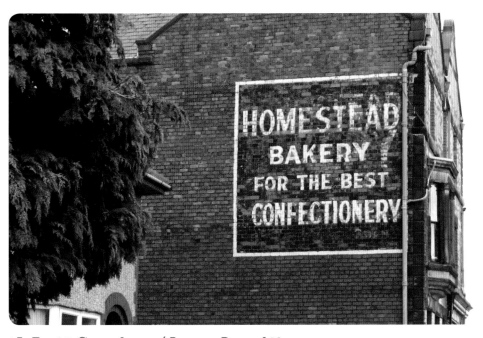

t No. 85 Green Lane / Russian Drive, L13

This sign was painted for Atkinson's Homestead Bakery, which is listed from at least the 1920s and was open for business until quite recently. This wonderful sign has sadly now been covered over by the current owner.

t The gold Atkinson's Bakery sign has now been removed from the shop front and the premises are now residential. The 'Russian Drive' & 'Leading to Kremlin Drive' street signs have also disappeared.

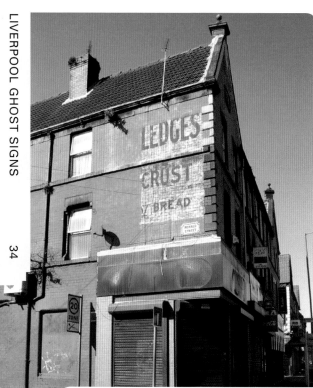

Prescot Road / Ronald Street, L13

This business was founded by James Blackledge in 1849, when he opened his first branch at No. 26 Fox Street. Around 1875, James Junior and John Blackledge joined the business and the company was then known as James Blackledge & Son. James Junior eventually became managing director and built a bakery at their Derby Road mill in 1888. Here they sold readymade bread, thereby becoming the first manufacturer of bread in England. The Blackledge business continued to thrive until the 1970s, when it was purchased by Mr Ossie Shaw.

↲ A fine example of a Blackledge delivery van in the late 1920s/early 1930s, proudly displaying the company's main product 'Gold Crust' bread.

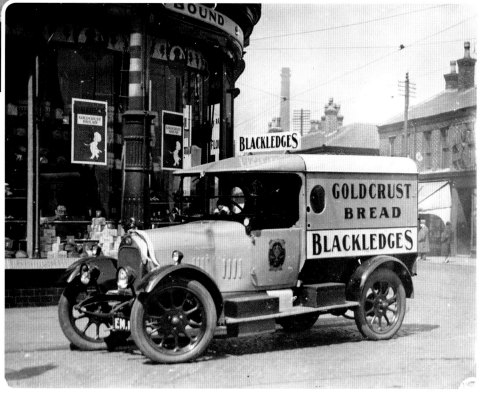

No. 356 Prescot Road, L13

This building housed the Stanley Billiard Hall from at least 1908. The term 'Stanley' refers to the area in which the building is situated, between Fairfield and Old Swan. There is also another ghost sign on the right-hand side of the building, but unfortunately it is currently covered with a modern billboard and is undecipherable.

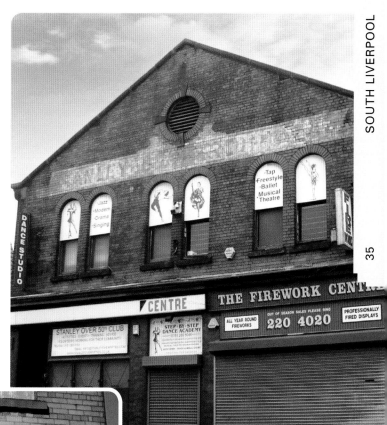

Aviemore Road, L13

This furniture removal business belonged to Herbert Wilkinson & Sons and was listed from 1923 at Nos 356/8 Prescot Road. The Wilkinson's also had premises at No. 3 Oakfield Road and No. 671 West Derby Road. By 1959 they had expanded to 'Coal Merchants and Demolition Contractors' and the 1970 Kelly's Directory sees them with premises also at No. 1a New Road and No. 13 Ardleigh Road. There is also a black wooden sign for St Cuthbert's School on this wall on the left of the photograph, which lies at the bottom of Aviemore Road.

➝Prescot Road / Bell Street, L13

Prebbles have left a legacy of two wonderful signs in Liverpool. This yellow ceramic sign is on the side of their former chemist shop at No. 536 Prescot Road, where they are listed in the 1930s.

❮ This set of mosaic panels are just off Kensington in Coleridge Street. They are wonderfully intact and prove how prosperous their business once was. The business was initially run by Ernest Prebble, who was later joined by his son – Harry Earlham Prebble.

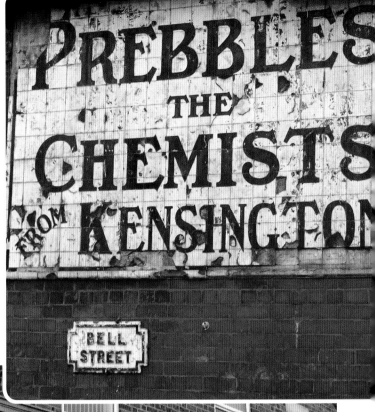

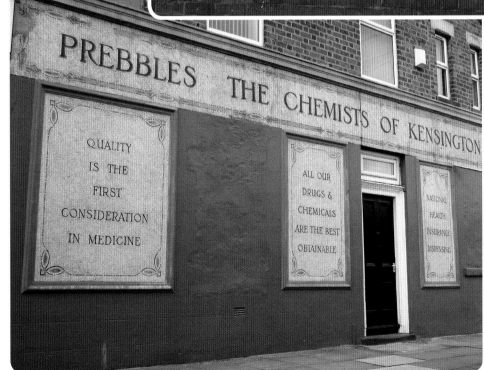

Nos 516-518 Prescot Road, L13

Leslie Cohen was born in Russia and found a home at these premises in Liverpool in around 1908. He was a household furnisher and, by 1925, had expanded his business to two shops, and three shops by 1931. We find Cohen here until 1983, listed as just one shop, which shows that the business must have declined in later years.

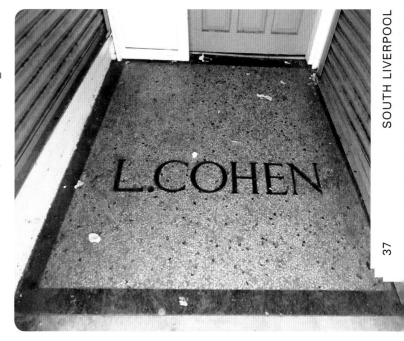

Malvern Road, L6

This is another fine example of an Emergency Water Supply (EWS) sign – a remnant of the Second World War and a vital part of people's safety, in case of fires.

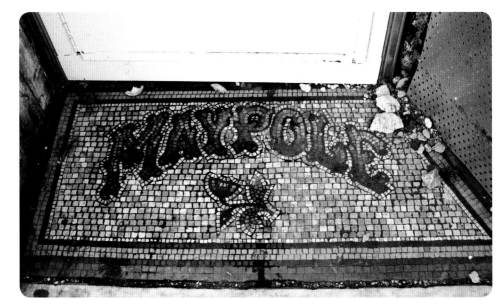

No. 130 Kensington, L7

The first branch of Maypole was set up at No. 67 Queen Street, Wolverhampton in 1887 by George Watson. George's brothers also had dairy businesses and this saw them join forces in 1898 to specialise in butter and margarine. The business boomed and Maypole became a household name. The margarine business slowly declined by the 1920s, owing to cheaper foreign imports, and the stores were eventually taken over by Home and Colonial Stores but still traded under the Maypole name until the 1960s. This mosaic step at No. 130 Kensington was part of a beautiful frontage that was recently demolished.

Gloucester Place, L6

From at least 1911 this building housed a bakery business. By 1923, Lucas & Sons, confectioners, had taken over and continued to thrive here until at least the 1970s.

TWO

LIVERPOOL CO-OPERATIVES

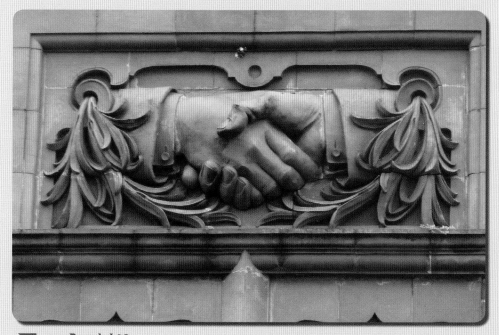

Eaton Road, L12
This handshake motif is seen on many former branches of the Co-Operative around the city, and symbolised unity.

Priory Road / Manningham Road, L4

This is a wonderful example of a building built specifically for the Co-Operative in 1925. As well as the main shop, it also housed a branch of the Co-Op dairy on the Manningham Road side of the building.

No. 12 Ashfield Road, L17

This former Co-Operative branch still displays an LCS tiled entrance step, and once boasted a panel on the side of the shop, which is now unfortunately covered over.

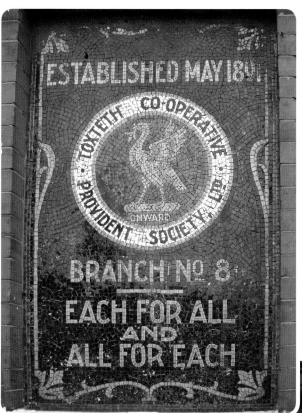

Ennismore Road / Prescot Road, L13

There are two current examples of this mosaic style panel in the city. They were commissioned by the Toxteth Co-Operative Society, which began in 1891 according to this panel.

Marlfield Road, L12

This beautifully tiled mosaic panel lies on the side of the Eaton Road branch of this former Co-Operative and proudly displays one of the society's mottos.

Beatrice Street, L20
Another well-preserved example of a tiled panel is seen here, still in its original position on the side of a former Co-Operative branch on Hawthorne Road.

Bedford Road, L4
This is another fine mosaic entrance step seen on the side entrance to a former County Road branch of the Co-Operative, displaying another of the society's mottos: 'Unity is Strength'.

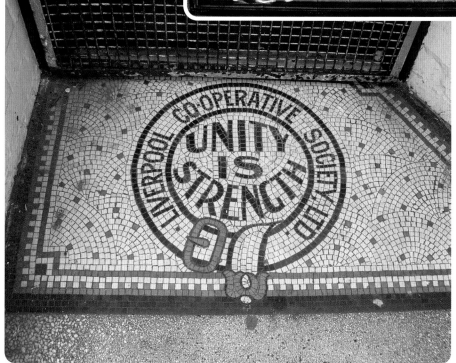

THREE

CENTRAL LIVERPOOL

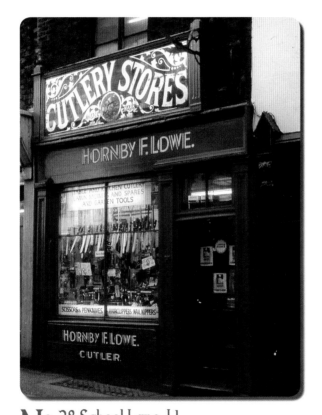

No. 28 School Lane, L1

Hornby Fletcher Lowe was born in 1858 in Liverpool. He is listed in the 1901 census as a cutler, living at 72 Deane Road. The business was on School Lane from at least 1880 and lasted until the mid-1980s. This beautiful shop sign was vandalised shortly after this photograph was taken and this block has since been demolished.

➔Ilford Street, L3

According to this sign, this site was acquired by the Salvation Army for their new 'Central Halls' and 'New Divisional Headquarters', yet this new building did not materialise at this location.

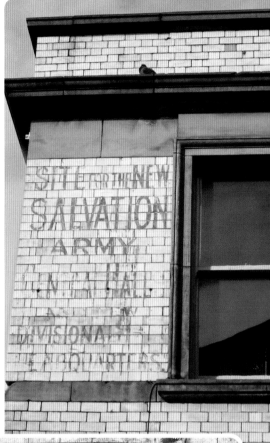

tLondon Road, L3

Woolworths opened its doors in the UK in November 1909 at Nos 25-25a Church Street, Liverpool. The opening ceremony saw fireworks, circus acts and a full orchestra. There was nothing in the store that cost more than 6*d*; this proved popular with the public and led to a string of stores opening across Liverpool and Merseyside, and indeed the UK. This mosaic step is an original feature of many 'Woolies' shops across the country, mostly on the original house-built stores. This particular example was sited at London Road, but unfortunately has now disappeared, as the building has since been converted into a Tesco supermarket.

No. 26 Gradwell Street, L1

Walter Patterson was born in Nottingham in 1887, but by 1911 we find him living in Bootle, listed as an 'Installer of Electrical Machinery and Lights'. He had premises at Stanley Road but, by 1922, has also acquired premises at Newington. We find him listed at Gradwell Street from the early 1940s, and by the late '50s Nicholas Hastie has also joined the business, and they are listed as 'Elec Contrs, Armature Winders'.

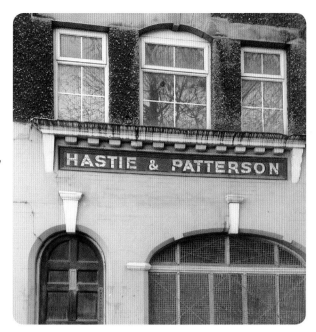

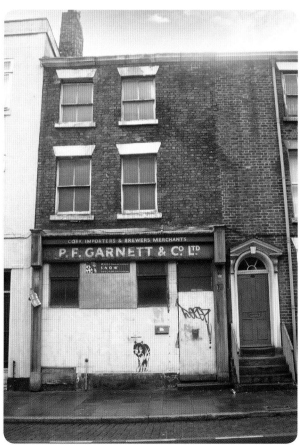

No. 135 Duke Street, L1

Percy Foster Garnett's Cork Importers and Brewers Merchants are listed at this address from 1937. Prior to this the firm were at No. 106 Leeds Street, from at least 1930. The firm are still at their Duke Street address in 1970. The building was 'acquired' by Snow architects (who are based at Blackburne House) a number of years ago, and was supposed to be incorporated into a new hotel development on Duke Street, although at the time of writing this has yet to be set in motion.

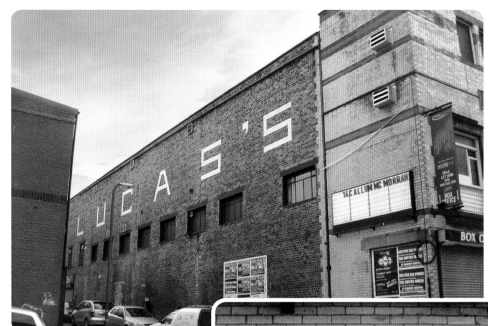

Nos 11-13 Hotham Street, L3

Lucas's was a repository for the sale of horses and carriages. They are listed at this address from 1886. Prior to moving to these premises, the business was located in Great Charlotte Street.

➡ This sign has been uncovered after having being hidden underneath bill posters for the 02 Academy, which is the current resident in the building. The lettering states 'Removals and Storage', which presumably relates to the business of Ray and Miles Ltd, who are listed at this address from at least the 1940s as furniture removers. Ray and Miles also had a furniture business on nearby London Road, from the late 1800s until at least the mid-1970s.

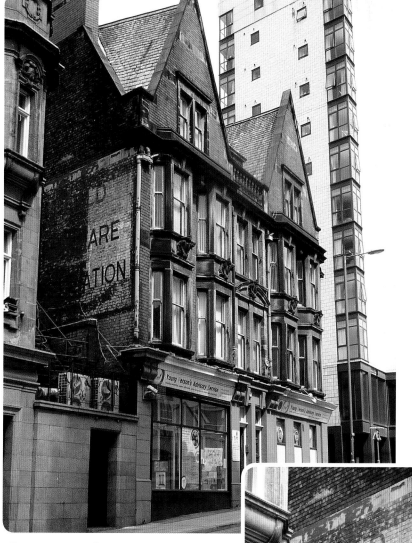

ᵗNos 9 & 11 Copperas Hill, L3

The Liverpool Child Welfare Association was founded by Margaret Beavan, the first female Lord Mayor of Liverpool. Originally established as the Liverpool Invalid Children's Aid Association, the body went on to found the Royal Liverpool Babies' Hospital in 1916.

➡ The sign has deteriorated over the past few years and has lost half of the lettering to an unknown cause, other than weathering.

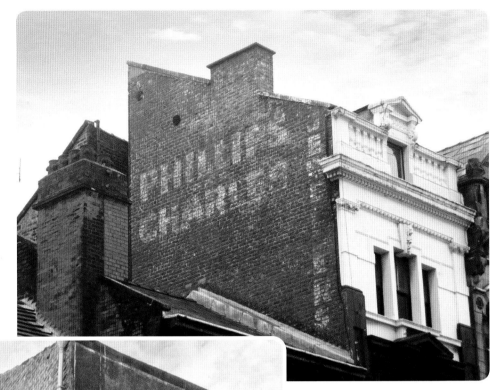

ᵗRanelagh Street, L1

Phillips & Co. and Charles & Co. started life as two separate businesses. Israel Phillips had shops on Lime Street from at least the 1880s, and later on is also listed as having an 'American Exchange Bank' on the premises. Edward Charles is listed at No. 17 Ranelagh Street from at least the 1890s. In 1970, the two businesses presumably merged to become Phillips & Charles, jewellers.

←No. 6 Fleet Street, L1

This sign has a lot of layers and there are a number of different things being advertised. One advert is the 'Freehold for Sale', and to apply to 'W. Mooney' for further information. (It is of interest to note that W. Mooney & Sons had premises at nearby School Lane, Manesty's Lane, College Lane and Hanover Street at varying times.) There is also another handwritten sign underneath this one. It appears to advertise 'Madura Ltd'. This business was run from this address by Edward Hughes from at least the 1930s.

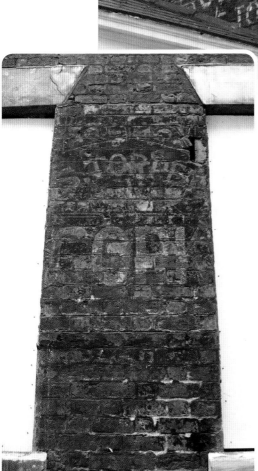

No. 9 Slater Street, L1

McGarron & Barron are listed at Nos 5-11 (and Nos 8 & 10) Slater Street, from the mid-1940s until at least the 1970s. From the sign we can gather they were garage equipment and tool dealers.

No. 48 Seel Street, L1

This sign was on the front of the building inhabited by Sylvester Torpey – cork merchants. Torpey was born in Ireland in 1856, and is listed in the 1881 census as a cork cutter. We find the business listed from at least 1891 at Seel Street and it seems this business is still running in some guise today, although from a different address from at least the 1980s.

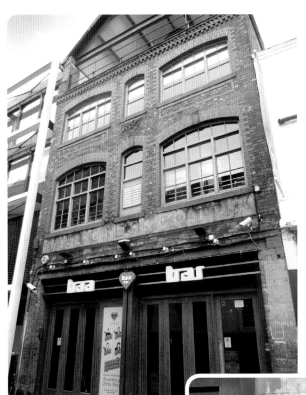

←Nos 43-45 Fleet Street, L1

This old frontage has thankfully been left in very good condition. H & J (Henry & John) Jones, established 1826, are listed at this address as Rope and Twine manufacturers in the 1950s. However, they did not stay for long at this property as they were listed at a different address by 1960.

→ A fine example of a company advertising their stock at pedestrian level: 'Ropes, Twines, Paper, Hessian, Wadding . . . '

No. 13 Hardman Street, L1

Kirkland's Bakery building is a familiar landmark in Liverpool city centre. It is Grade 2 listed and boasts many fine features – from its crest 'By appointment', 'Bakers to the Queen', to the beautiful gilt lettering and also the intricate mosaic step (shown below).

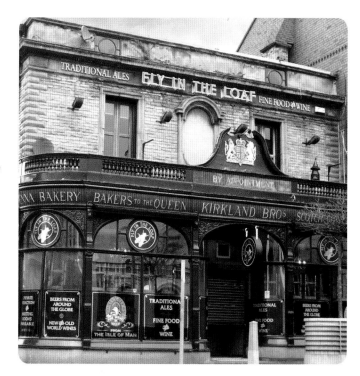

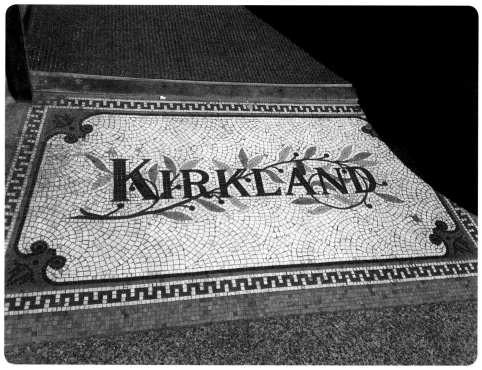

⬆ This building was built for Kirkland Brothers (Richard and George) and opened in 1881. In the 1938 directory – Kirkland's had twenty-five branches across the city, including Aigburth, Toxteth, Huyton and Garston.

Nos 35-37 Leece Street, L1

There seems to be a few different layers of advertising on this sign, which is quite common on older buildings. The lettering that stands out is 'Daniel Davis', whose occupation was furrier. Mr Davis' business did not last long at these premises – we find him here in the late 1920s but by the early 1930s Binder & Cornforth, fireplace manufacturers, are listed here. Daniel also had shops in nearby Bold Street and also County Road. From 1941 this building has been a post office.

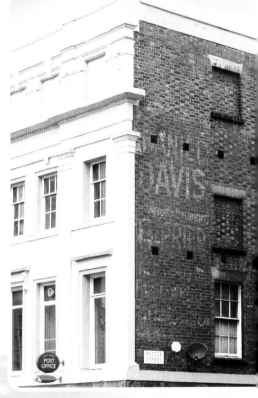

Nos 20-26 Benson Street, L1

Ayrton Graham were shop fitters and they are listed in the street directories from at least 1925, when they had premises in Duke Street and Back Gill Street. By 1935, the street directory lists 'Climax Woodwork Co.' at No. 24 Benson Street. This part of the street has now been demolished and the sign lost.

No. 39 Knight Street, L1

Joseph Glover was born in 1861 in Liverpool. He worked as a plumber from at least the age of 20 and eventually opened his own decorators and household contractual business at No. 39 Knight Street. He was at this address until the early 1930s, possibly until his death in 1932.

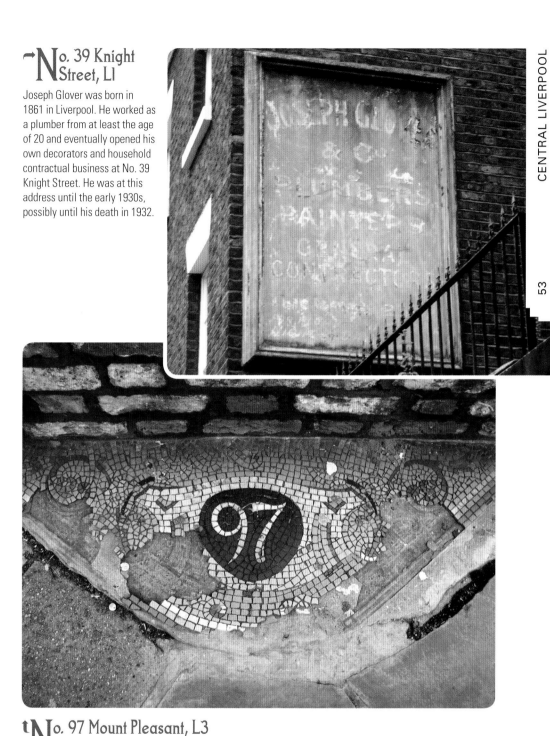

No. 97 Mount Pleasant, L3

This beautiful mosaic step was once the entrance to the chemist of Edwin Harriman. He is listed at these premises from at least 1911. Prior to this, in 1881, we find Edwin at No. 138 Brownlow Hill, which served as both the location of his chemist business and as two dwelling houses. By 1932, Edwin's son, Hubert, has joined his father in the business and he carried on the Harriman name (after his father's death in 1938) until at least 1955. By 1960, the building housed a surgical appliance company and also a glass depot.

The House of G·H·LEE & Co LTD
Basnett Street Liverpool

TO-DAY Lee's is the most popular rendezvous of fashion in Liverpool. It is not a mere shop. It is a meeting place where one feels comfortable and at home in an atmosphere of all that is best, both in merchandise and service.

LEE'S offer the facilities of a town club. Visitors to Liverpool will find Lounge, Writing, and Dressing Rooms at their disposal. Every convenience for perusal of the day's news or the conduct of one's correspondence will be found here—without obligation of any kind whatever, of course.

OUR service includes the most delightful Hairdressing Salons in the North of England, while the Restaurant offers a cuisine that would be difficult to equal out of London.

For current Fashion Notes and news of interest concerning everything for personal wear, the home and garden, see our announcement every TUESDAY in the "SOUTHPORT VISITER."

GEORGE HENRY LEE & CO. LTD. - LIVERPOOL.
Telephone ROYAL 4181 (10 lines). Telegrams : " Basnett Liverpool."

ᵗWilliamson Square / Basnett Street, L1

George Henry Lee was founded in 1853 by Henry Boswell Lee, and began trading as a bonnet warehouse at Basnett Street in the city centre. The shop eventually developed into a department store and began to prosper, also moving to nearby Williamson Square into a more prominent building. The business changed hands a number of times before being sold to the John Lewis group in 1940.

← This advertisement is taken from the Southport directory of 1924/5. It is very stylish and shows just how fashionable the store once was.

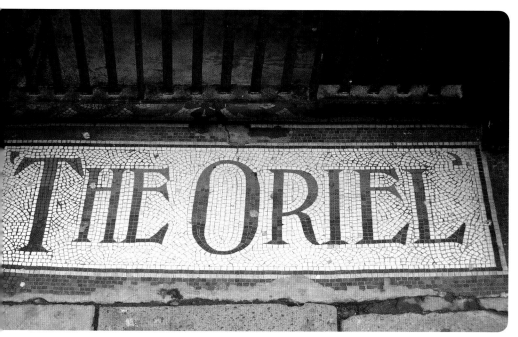

tWater Street, L1

The Oriel is a Grade 1 listed building designed by Peter Ellis and built in 1864. The building initially sparked outrage when it was completed, since it was ahead of its time and very modernistic. Since at least 1965, it has been used by a number of barristers for offices. In 2008, Oriel Chambers was named one of 'Britain's 50 Most Inspiring Buildings' by the *Telegraph*.

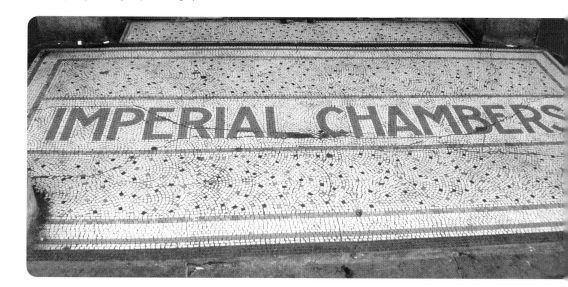

tNo. 62 Dale Street, L1

This lovely mosaic was possibly created by one of the many Italian craftsmen resident in Liverpool's 'Little Italy' quarter around the Scotland Road area. It stands at the entrance to a beautiful Victorian Grade 2 listed building in the city centre.

→Eberle Street, L1

During the Second World War, these Emergency Exit signs would have been a common sight to Britons. It is an unusual addition to this collection yet it is a vital part of our social history. There is a chance, however, that this sign could be a remnant from a film set, as it looks in suspiciously good condition for its supposed age.

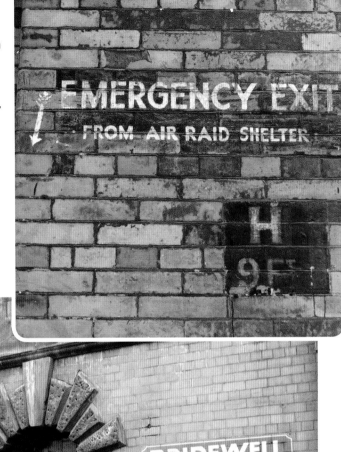

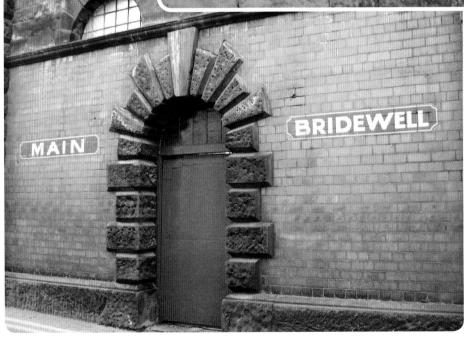

↑Cheapside, L2

The Main Bridewell was built around 1857 by John Weightman, who was the Corporation Surveyor. Weightman also designed the museum and library on William Brown Street, as well as the municipal buildings on nearby Dale Street. The bridewell has recently been sold for redevelopment.

ᵗS̲t John's Lane, L1

This was the entrance to one of many public conveniences dotted around the city. Unfortunately, due to antisocial behaviour, a lot of these facilities have been closed. They are an increasingly fading sight on our streets and are worthy of being recorded.

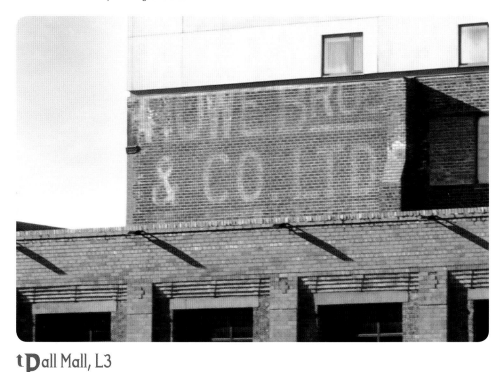

ᵗP̲all Mall, L3

Rowe Brothers were lead merchants and were listed in Pall Mall from at least 1900 until the mid-1960s. In 1970, Rowe-Dodd are listed at the address as plumbers' merchants – presumably, this was a branch of the Rowe family. By 1975, there is no mention of Rowe Bros or Rowe-Dodd in the phonebook.

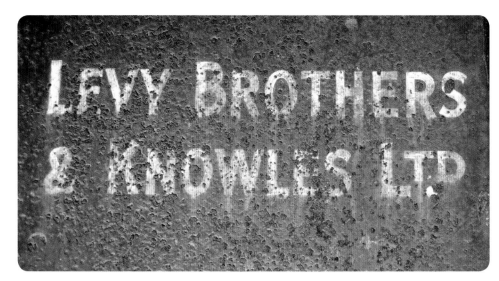

No. 28 Henry Street, L1

Levy Bros & Knowles are first listed at Henry Street around 1931. Their line of business was sack and bag manufacturers. They were another company who moved around quite a lot within a small vicinity. They had premises at Brunswick Street and Forrest Street and also offices in Glasgow, Hull, Bristol, Belfast and London. The firm is still in operation under the guise of LBK Packaging.

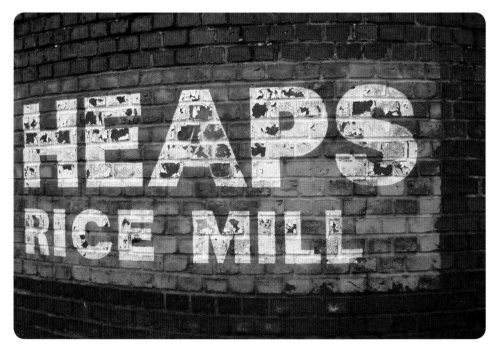

Upper Pownall Street / Beckwith Street, L1

Joseph Heap & Sons had a rice mill on this site from at least the 1870s. Until recently, the firm had a silo on Regent Road in Bootle. This building has been uninhabited since at least 2004 and is looking in rather a sorry state.

FOUR

CIGARETTE ADVERTISING

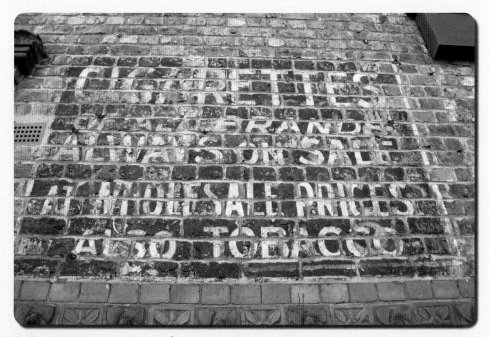

No. 156 Stanley Road / Lambeth Road, L20

This sign is very nicely preserved. It advertises 'Cigarettes of all brands always on sale at wholesale prices, also tobacco.' From 1918 until 1925 at least, this was George Palmer's cocoa rooms, and in 1935 it is listed as a horse flesh dealer. This sign probably dates from the 1960s, when it was a confectioner's shop run by Mr E.R. Wolstenholme.

No. 95a Sefton Road, L21

This sign was recently uncovered after being hidden behind a modern billboard for a number of years. In 1935, Frederick Underwood is listed at this address as a shopkeeper and by 1949 Mrs Phoebe Underwood is listed here.

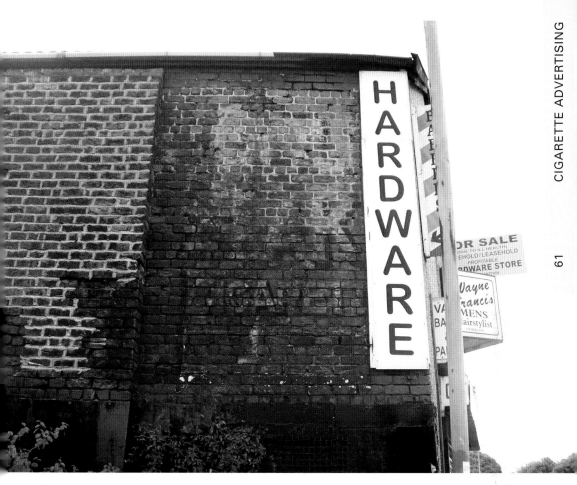

↑ This sign was uncovered on the same building as the previous picture. Star Cigarettes were just one of the brands manufactured by Wills'; a company that pioneered canteens, free medical care and paid holidays for their employees. Their Bristol factory was the largest cigarette factory in Europe when it opened in 1974. The building later featured in an episode of *Doctor Who*.

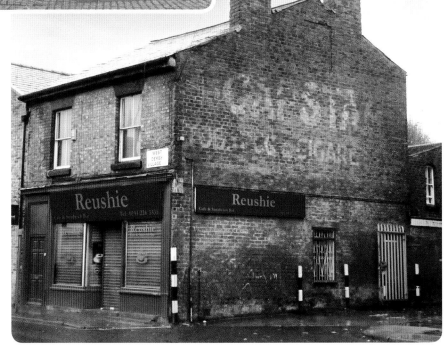

↰ Adelaide Road/Kensington, L7

This shop has seen a few businesses come and go over the years, from a grocers in the 1930s and radio engineers in the mid-1950s, to a confectioner in the 1960s, which is when this sign probably dates from.

t No. 19 West Derby Village, L12

This building has also held a number of businesses, including a chemist and druggist, newsagents and also refreshment rooms. This Capstan sign harks back to a time when cigarette advertising was at its height, in the 1930s and '40s.

FIVE

NORTH LIVERPOOL

Blessington Road/Atwood Street, L4

This was presumably the 'Meat Stores' for Lancelot Purslow, who ran a butchers' shop for many years at nearby Breck Road. This sign was painted by a local signwriter named George Henry Tubbs, who was active in the 1930s until at least the '50s – we can see his signature in the bottom right-hand corner of this sign. George's father was also a signwriter and a letterpress printer. In 1901, George's cousin was boarding with the family, and he is listed as a comedian!

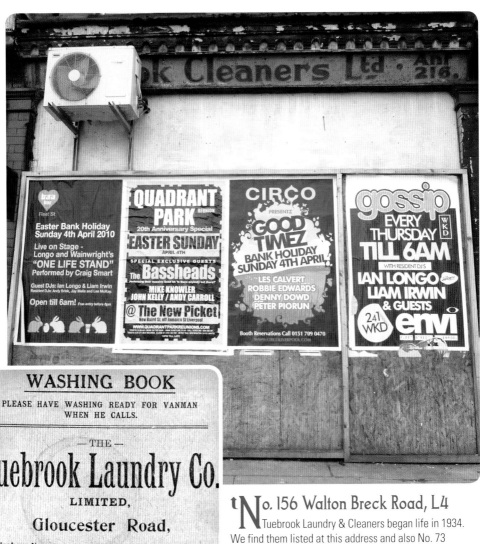

WASHING BOOK

PLEASE HAVE WASHING READY FOR VANMAN
WHEN HE CALLS.

— THE —

Tuebrook Laundry Co.

LIMITED,

Gloucester Road,

Telephone No.
ANFIELD 216 LIVERPOOL.

Receiving Depot:

156 WALTON BRECK RD., LIVERPOOL.

Name

Address

Laundry Mark

TERMS—CASH WEEKLY unless otherwise arranged
at the Office.

OUR Customers' attention is directed to terms on pages
2 and 3 of cover upon which work is accepted and which are
those adopted by Members of the Launderers' Association

Printed Receipt only Acknowledged.

t No. 156 Walton Breck Road, L4
Tuebrook Laundry & Cleaners began life in 1934. We find them listed at this address and also No. 73 Gloucester Road, among other branches, until 1976, when they were taken over by Afonwen Laundry.

← A page from a 'Washing Book' belonging to a former customer of Tuebrook Laundry Co., who was living in Elm Vale. It is interesting to note the wording at the top, which reads 'Please have washing ready for Vanman when he calls'.

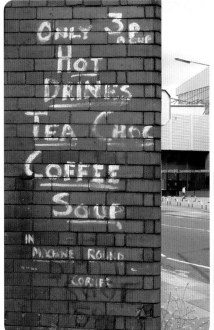

No. 199 Oakfield Road, L4

The first Mitchells Bakery was opened in Mill Street in 1926 by Richard Mitchell, yet, due to slum clearance in this area, they re-located to Marsh Lane, Bootle. In 1965, they moved to No. 199 Oakfield Road, Anfield. The bakery closed in 2010 and the building was recently used as a Biennial project named '2Up2Down'. The sign harks back to a much simpler way of life, when a cup of tea cost 3p!

Neston Street, L4

Edward Tillsley was born in 1874 in Warwickshire. He started his working life as a carpenter in Alcester but by 1901 he was living in Liverpool and working as a 'milk checker'. By 1911, he had his own dairy business in Stanley Road, and from at least 1915 he is listed at Neston Street. The bottom right-hand corner of this sign states 'Agent for Economic Supply Club'. Checking the directories, this club had various branches across the city, including a main branch on Stanley Road.

No. 16a Georges Road, L6

A street directory advertisement for F.H. Gell – one of the many signwriters working in Liverpool in the 1950s. As the years pass by, we can see the profession diversifying from handwritten signwriters to include more modern examples such as neon signs, plastic signs and mass signage.

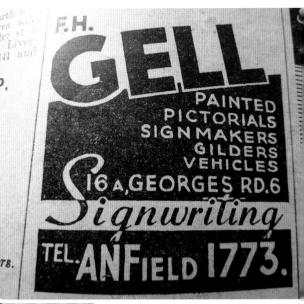

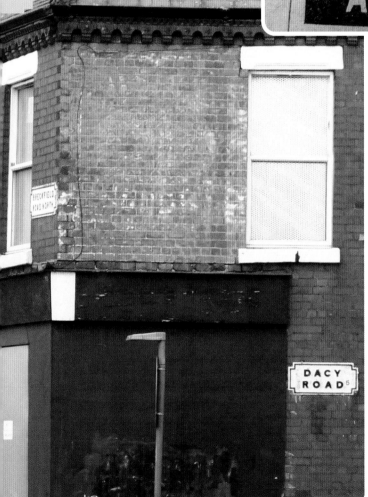

Dacy Road / No. 112 Breckfield Road North, L5

Thomas Wilson was born in Bradford in 1854, and he is listed in the 1901 census living in Everton with his wife, Matilda, who was a laundress. In 1904, the Wilson's are first listed at this address in Breckfield Road North with their own laundry business. They served this community until 1972, when their business disappears from the telephone book.

No. 134 Goodison Road, L4

This was one of many dairy premises around the city. This particular sign is on the front of Spellow Farm Dairy. The name Spellow derives from the ancient Spellowe House, which stood in the vicinity in the thirteenth century. In 1911, there are two professional footballers (John Borthwick and William Stevenson) listed at this address living with the cow-keeper's family!

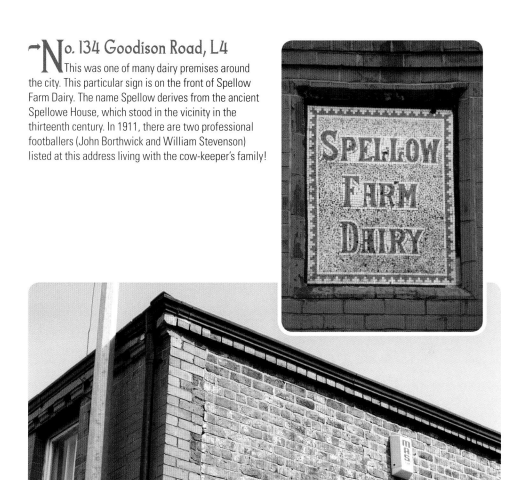

This sign is on the side of Spellow Farm Dairy. The cow-keeper displayed on the sign is J. Raw. He was listed here from at least 1901 until the late 1920s.

No. 61a Walton Road, L4

This is a nice example of two different signs for two completely different businesses housed in the same building over the years. The top sign is advertising a former chemist, while the red panel (now painted over) once displayed a sign for John Irwin's grocer's store, which once inhabited this address.

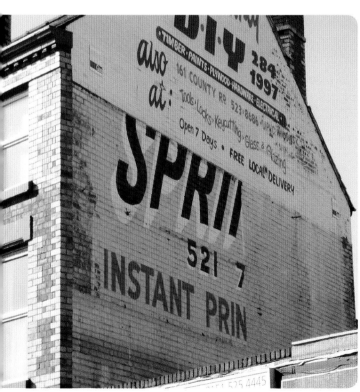

Nos 127-129 County Road, L4

This is a relatively modern ghost sign, and was painted to advertise 'Sprinter, Commercial Printers', and their 'Instant Prints'. They are listed at this address in the late 1980s. However, by 1993 the business does not appear to be listed.

ᵗNo. 129 Westminster Road, L4

Samuel Gordon had a grocery chain in Liverpool from at least 1913 until the 1960s. He was only at these premises for five years - between 1929 and 1933 – but left his mark with this lovely sign.

No. 148 Peel Road, L20

This barber shop was started by John McPherson in 1905; it originally had five barbers' chairs and also sold confectionery and cigarettes. John's son, Tom, began work in the shop just after the Second World War, and after his father passed away he took control of the business. In 2005, it celebrated its 100th year of business.

No. 45a Foley Street, L4

This shop once belonged to Henry Albert Rogers, who was born in Liverpool in 1855. Henry lived with his family at Tatlock Street, yet by 1891 we find him listed at this address in Foley Street with a furniture business.

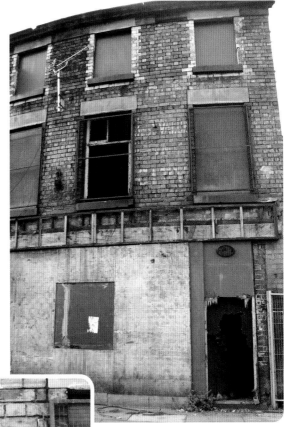

← This photograph shows a close up of one of Rogers' advertising signs 'Best Value in City'. Rogers moved to nearby No. 354 Westminster Road from at least 1901 until 1911, yet by 1921 he has moved back to his shop at Foley Street.

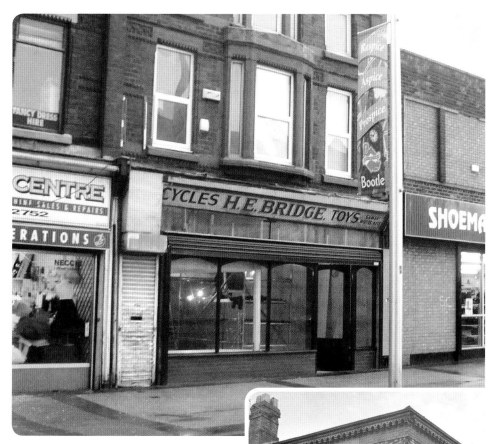

tNo. 300 Stanley Road, L20

Another shop sign that was uncovered during renovation of the premises in the past few years. Harry E. Bridge sold toys and bicycles, and is listed here from at least 1960 until at least the mid-1980s. He also had premises in nearby Hawthorne Road.

No. 245 Stanley Road, L20

This was the tailors of Robert Thomson. The Thomson business is listed at these premises from at least 1889 until at least 1975, although the business also acquired Nos 241 and 243 Stanley Road at some point. Robert Thomson was born in about 1849 and died in 1899 in Liscard, Wirral. His son, Charlie Harry Thomson, is listed on the 1901 census as a 'Master Tailor' and presumably carried on the business after his father. By 1980, the business is no longer listed in the telephone book.

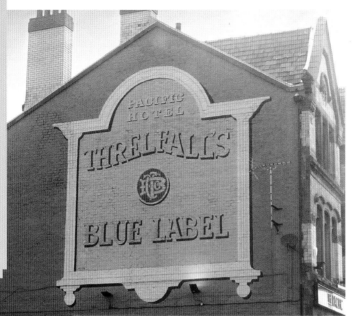

No. 168 Linacre Road, L21

This ghost sign for Threlfall's Blue Label was discovered when the adjoining building was demolished. Today, it has been thoughtfully restored to its former glory.

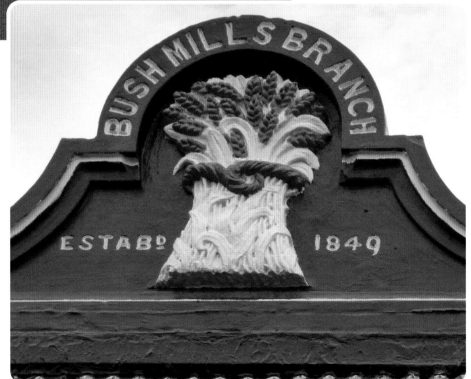

Seaforth Road, L21

This date stone sits on top of a former branch of Blackledges in Litherland. In the 1930s, this building was a confectioners run by Mr Harry Mentel. In later years, the Prudential Assurance occupied the building.

No. 97 Linacre Road, L21

Kings' Grocers are listed in the street directory from at least 1905 until at least 1958. John J. King seems to have thrived on Linacre Road, offering 'Kiel butter' and 'high class provisions & groceries at lowest possible prices', yet, by 1960, another provision dealer has taken over the business. When we look again in 1970, the building has become a turf commission agent.

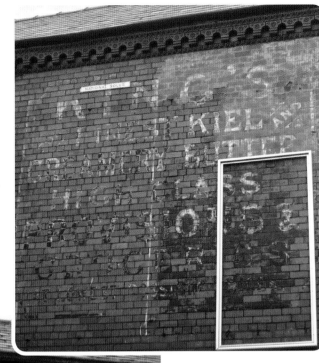

No. 107 Linacre Road, L21

This sign advertising Hovis is on the side of a former bakery in Litherland. The Mason family ran the bakery from around 1900 to at least 1970. The business appears to have passed from Alfred Mason to his daughter Frances Helena Mason. In recent times, it has become a discount store.

No. 31 Sefton Street, L21

This sign is advertising Richard Baxter Lee's chemist shop, and also Richard Sherwood's chemist at differing times. Lee was also sub-postmaster and was at these premises from at least 1894 until the mid-1930s. By 1938, Robert Sherwood has taken over the business and added his name to the sign, but did not stay for long as Valins Chemist is listed here from at least the late 1940s. The building was featured in the film, *51st State*, when it is still clearly Valins' Chemist.

Nos 4-6 Chelsea Road, L21

Here we have a few layers of ghost signs relating to various dairymen that have inhabited this property over many years. Edwin H. Hill was listed here from at least 1900 to at least 1931; although during the mid-1920s Hill Bros and Alfred Henry Hill are listed at this address. Dairyman John Mawer is listed here briefly in the late 1930s, yet by 1943 the Bownass family (also dairymen) have taken over the property and remained here until the mid-1960s.

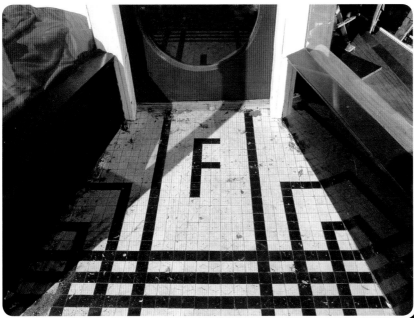

ᵗNo. 16 Bridge Road, L23

This wonderful letter 'F' stands at the entrance to the former hairdressing shop of Pasquale Famiglietti. Pasquale was listed at these premises from the early 1920s through to the 1950s. Herbert of Liverpool, a fellow hairdresser, occupied the shop in the 1960s.

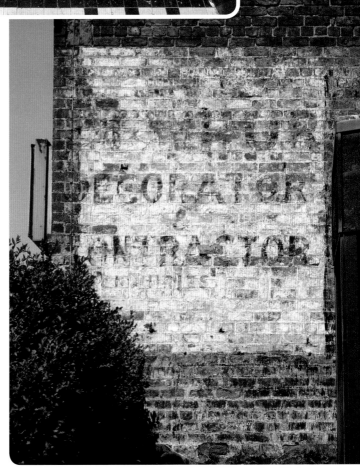

→No. 7 Church Road, L22

This building once housed Wigan Coal Corporation, but by the 1940s it belonged to a furniture dealer. This sign promoted the business of R.D.W. Dewhurst, decorator and contractor, who inhabited the building from the late 1940s until at least the 1970s.

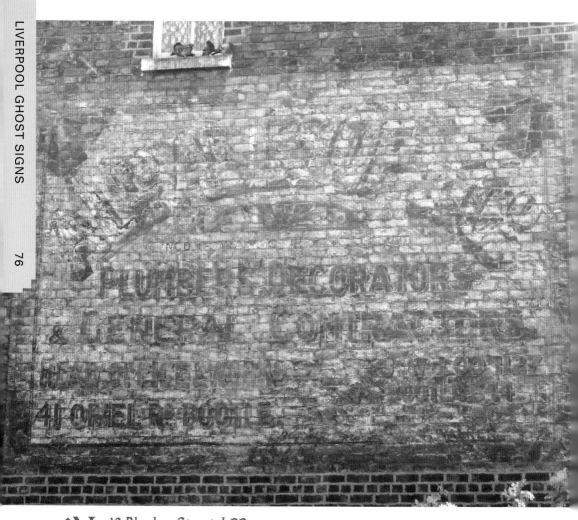

t**N**o. 18 Blucher Street, L22.

This magnificent sign was commissioned by Alfred Allsop to advertise his plumbing, decorating and general contractors business. Alfred is listed at this address from at least the 1930s until at least the 1970s.

→**D**alrymple Street, L5

This was the premises of Schofield Bros, mineral water manufacturers. The brothers were John, Samuel and Thomas, and the business was first listed at this address in around 1894. Prior to this, the brothers are listed at Leycester Street, which was near their family home in Penrhyn Street. The business also produced lemonade and was in operation until around the mid-1990s.

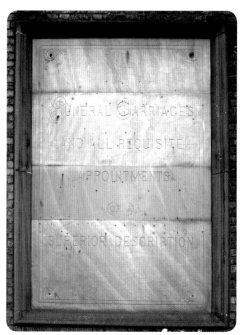

No. 66-72 St Anne Street, L3

William and Daniel Busby are listed at this address as early as 1880, working as 'Coach and Car Proprietors' and 'Funeral Furnishers'. This panel states 'Funeral Carriages and all requisite appointments of a superior description'. This panel (and also a similar one on the opposite side of the entranceway) possibly date to around the 1890s, as their business is no longer listed at this address from 1904.

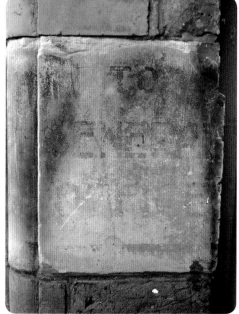

→ This sign reads 'To General Office' and is situated at the entrance to the building on St Anne Street. From at least 1904, Lawrence Kiezer is listed here. His business was a carver and gilder, locking-glass manufacturer, and agent to the British Plate Glass Co. The business is listed in the same name up until at least the 1960s.

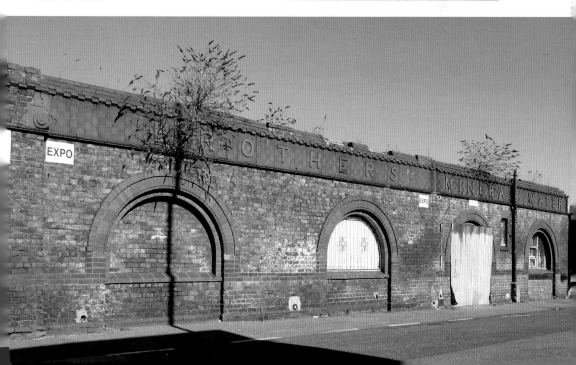

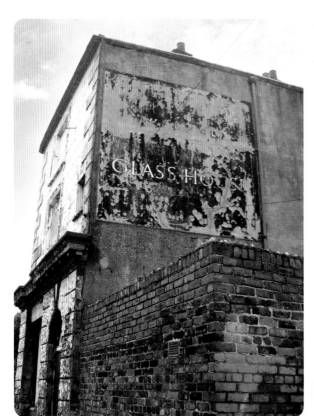

↰Vauxhall Road / Eldon Street, L3

This pub had been named the Glass House since the 1860s and was so-called after a former glass works in Bond Street. This sign has now been painted over, and the building has been refurbished as residential premises.

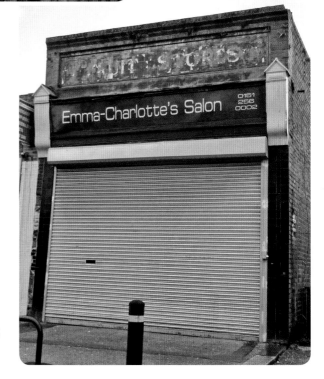

→No. 52 Larkhill Lane, L13

Waterworth Bros were a successful fruiterer's chain in Liverpool and this picture shows one of their former 'Fruit Stores'. The brothers opened their first shop in Granby Street in the 1880s.

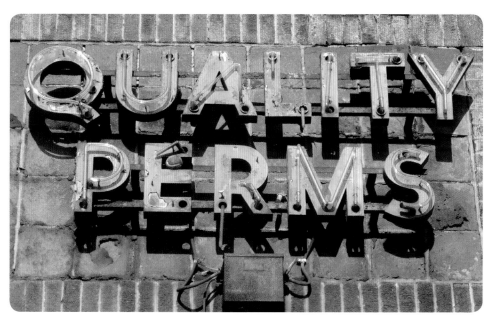

t No. 438 Queens Drive, L13

Between the 1960s and the 1980s this building was a hairdressers belonging to Thomas Stephens. Presumably he commissioned this great sign, advertising his 'Quality Perms'.

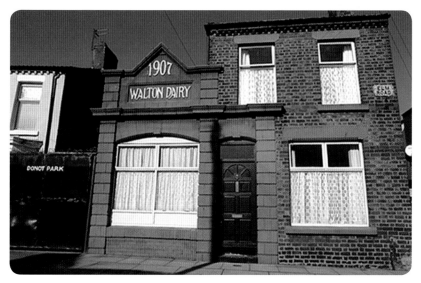

t No. 45 Elm Road, L4

This wonderful building was inhabited as a dairy business from at least the 1880s until the early 1950s. The date '1907' emlazoned on the frontage refers to the date that Mr Job Gadie took over the tenancy of the premises; we find Job listed here until the early 1930s, when he moved to No. 1 Whittle Street. Various other proprietors are listed here after this, including George Thomas Thompson in the 1940s, and then the Rushton family until the early 1950s, after which it became a residential property.

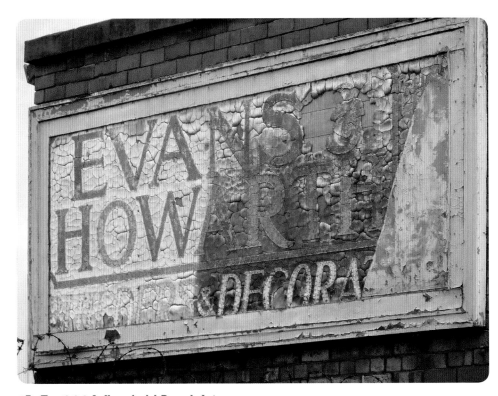

No. 288 Whitefield Road, L6

Evans & Howarth, builders, were listed at this address from at least 1915. By 1929, they are listed at new premises on Queens Drive, and later Druidsville Road, where the business continued until the late 1940s. This sign probably dates from pre-1928, when the business was last listed in the phonebook at these premises.

SIX

JOHN IRWIN & SONS

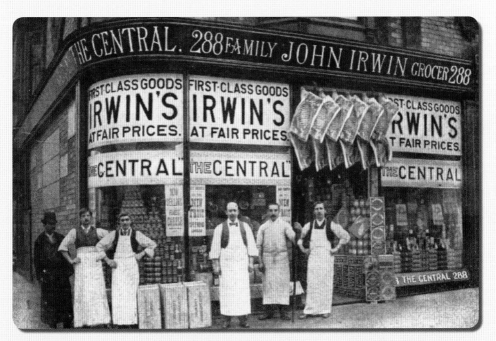

John Irwin moved to Liverpool from Northern Ireland in 1862. Following the failure of two grocery shops in Kirkdale, John travelled to America to gain experience. On his return in 1874, he started his own business at No. 101 Westminster Road, Kirkdale. The Irwin name continued to flourish throughout Merseyside and North Wales, until the business was bought by Tesco in the 1960s. This photo is a wonderful example of an early Irwin's shopfront – with proud staff standing outside.

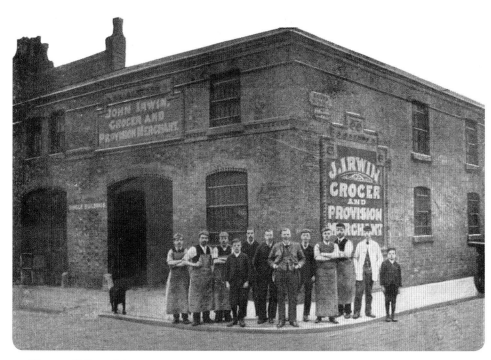

tOrwell Road, L4

This picture shows John Irwin's first warehouse at Orwell Road, with a proud workforce standing outside. The building has now sadly been demolished. The man in the centre of the photo is believed to be John Irwin himself.

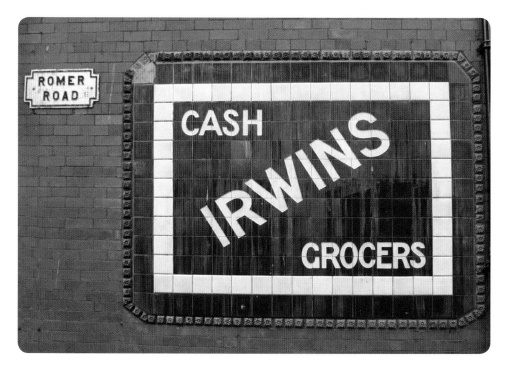

Green Lane, L13

This wonderful façade has thankfully been kept in near original condition. The stonework at the top still proudly bears the name of 'John Irwin Sons & Co. Ltd'.

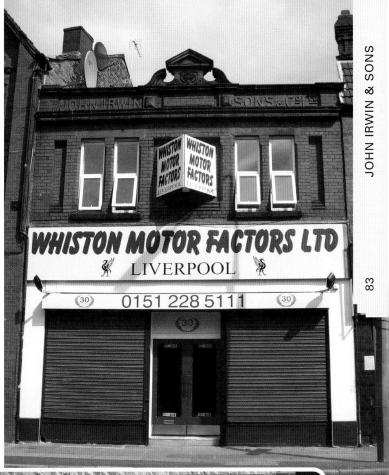

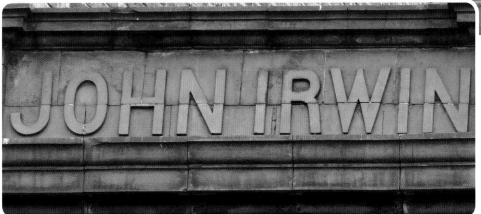

Green Lane, L13

A close-up of the wonderful stonework on the above façade.

Romer Road, L6

This is a typical example of a tiled sign that Irwin's used to advertise their chain of shops. This particular example is currently covered with a new advertisement.

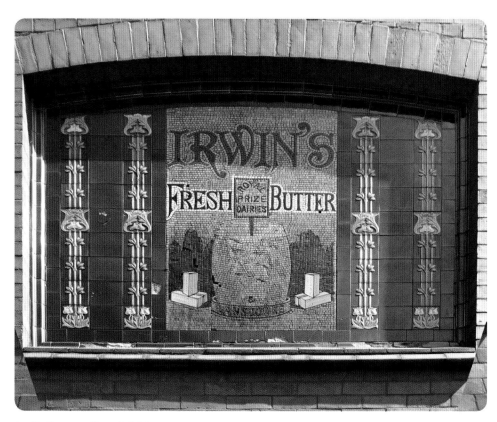

t A llerton Road, L18

One of the finest mosaics in Liverpool, this sign proudly displays 'Irwin's Fresh Butter' and also 'Royal Prize Dairies'. The business must have been flourishing when this sign was commissioned.

SEVEN

MOSAICS

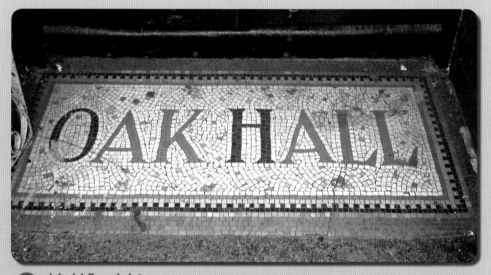

Oakfield Road, L4

Oak Hall Buildings have a date stone of 1902, and in 1904 we see a variety of businesses housed here; George Herbert Lloyd (cycle repairer), Thomas Hartill (umbrella maker and hairdresser!), Miss Elsie A. Roberts (draper) and Miss Marion Clare Trampleasure (confectioner).

→No. 31 Cheapside, L3

This former public house stands opposite the former Main Bridewell on Cheapside and once had the name of the Bridewell Vaults. From at least 1910, this building housed the business of S. McCain, grocer and egg importer. He is listed at this address until at least the early 1960s.

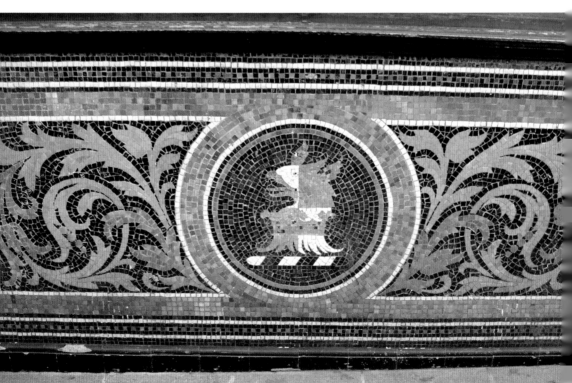

↑ A close-up of the wonderful mosaic frontage. It is sad to note that the building is not listed and currently stands vacant.

No. 15 Lord Nelson Street, L3

This ornate entrance step can be found on a house opposite Lime Street station. Through the years it has been a victualler's premises and also a temperance hotel. From at least the late 1950s this was Parry's Hotel; it now appears to be a residential property.

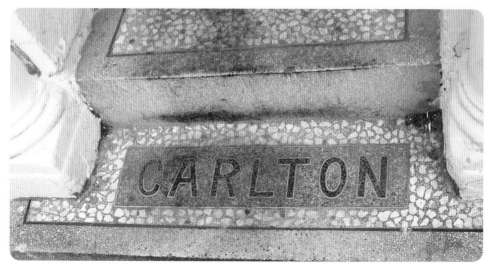

No. 11 Lord Nelson Street, L3

This was one of many temperance hotels on this street in the early part of last century. The temperance movement in the UK started life in the nineteenth century, and Liverpool housed many such establishments to cater for its followers, including nearby Mount Pleasant. This building also housed the Carlton Hotel from at least the late 1950s until the '70s.

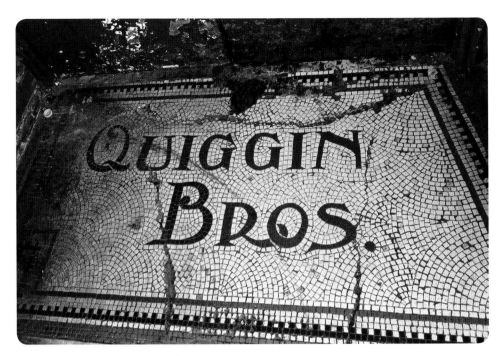

tNo. 75 Renshaw Street, L1

William Charles and James Henry Quiggin were listed at this address from at least 1904 until the mid-1980s as ironmongers. Their father was also an ironmonger by trade, he died in 1879, and his sons carried on the business. In 1984 the business moved to No. 45 Duke Street, yet by 1986 it ceases to be listed. The Quiggin name lives on in the form of the alternative shopping arcade that moved into No. 75 Renshaw Street around 1986 and kept this wonderful mosaic entrance step. This business outgrew this address and moved to the corner of School Lane, where it flourished for many years. Following a Compulsory Purchase Order, in conjunction with the new Liverpool One development, Quiggin's closed, with some of the tenants moving to nearby Central Hall on Renshaw Street.

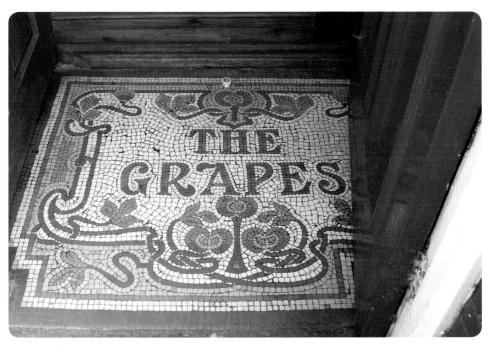

tNo. 87 Renshaw Street, L1

This mosaic step stands at the entrance to a public house once known as The Grapes (from at least the 1920 to the 1940s). The pub is now known as The Dispensary and was bought by Robert Cain's in 1998

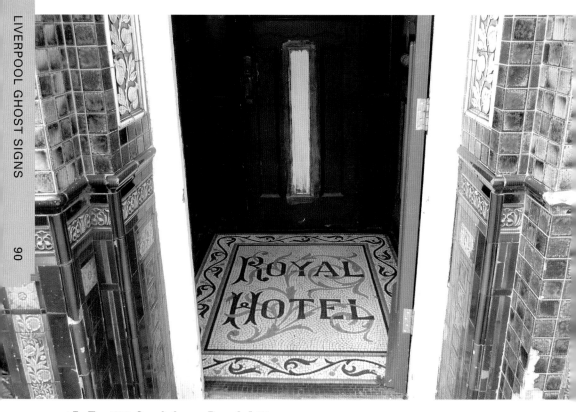

No. 213 Smithdown Road, L15

From at least 1911, this public house has been known as The Royal Hotel, prior to this it was called The Angel Hotel. This name change was presumably to coincide with George V's coronation in June 1911. This beautiful façade is in lovely condition and has two mosaic entrance steps.

No. 276 Smithdown Road, L15

This mosaic was commissioned for the Hatfield Hotel public house around 1896. The building was erected by Burton, Bell & Co. who had a brewery in Wavertree, yet the licence was repeatedly refused by the authorities, thanks to petitions from local residents. This was mostly due to the fact that a 'gin palace' opposite the newly laid out 'Wavertree Playground', was seen as an insult to the generous donor whom had offered the funds to lay out the park.

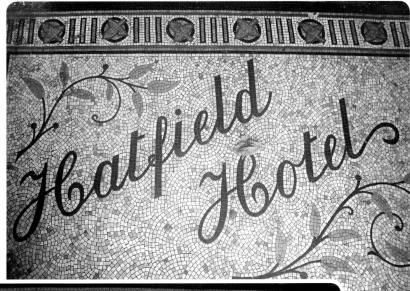

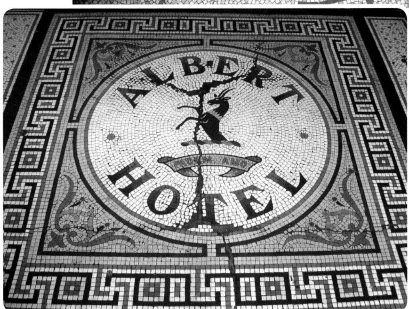

Nos 66-68 Lark Lane, L17

The Albert Hotel was erected in 1873 by Robert Cain and we can see his brewery's motto *Pacem Amo* (I love peace) on this fantastic mosaic entrance step. This is a listed building and stands within the Lark Lane conservation area.

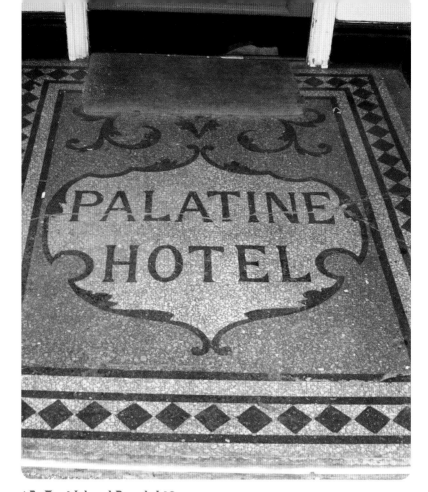

No. 1 Island Road, L19

The Palatine Hotel stands on the corner of Island Road and Woolton Road in Garston. In 1901, the licensee was Mr George Ubsdell, who had been a professional cricketer. Ubsdell was born in Hampshire in 1845 and played in fifteen first class matches for Hampshire between 1864 and 1870. In 1891, he was living in the Cricket Ground Lodge at Riversdale Road in Garston. He died in 1905, and in 1911 his widow, Louisa, is listed as still running the Palatine Hotel.

No. 76 King Street, L19

This step advertises King Street Vaults, but this pub was known locally as McGarry's as, for many years, it was run by various members of the McGarry family.

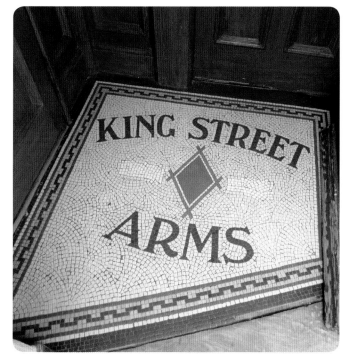

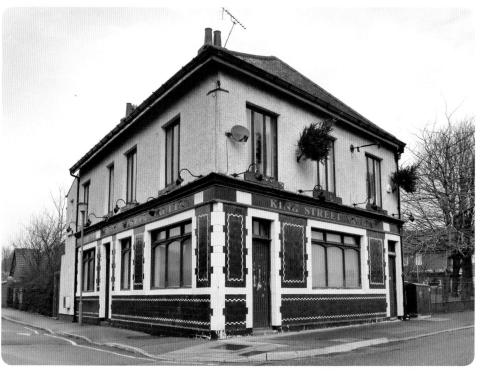

⬆ The King Street Vaults. Note the green and white tiling. The surrounding area is currently being regenerated, and this pub currently stands isolated.

ABOUT THE AUTHORS

Caroline and Phil Bunford are keen local historians and have contributed to various heritage websites and projects; they are also spokespeople for the 'Ghost Signs' archive. They have been featured in local and national media, and are keen researchers. They live in Liverpool.

BIBLIOGRAPHY

Books

O'Connor, Freddy, *A Pub on Every Corner Volume 3: North Liverpool* (Bluecoat Press, 1998)
Riddick, Brenda, *Remembering Blackledges* (unknown publisher)
Scott, Duncan, *Urban Cowboys: Lost World of Doorstep Milk* (DWS Publications, 2010)
Sharples, Joseph (ed.), *Pevsner Architectural Guides: Liverpool* (Yale University Press, 2004)
Woolley, Peter W., *Bootle and Orrell* (Tempus, 2004)
Lewery, A.J., *Signwritten Art* (David & Charles, 1989)

Websites

Ancestry.co.uk
Find My Past.co.uk
Historical Directories Online

Other

Kelly's Directories
Gore's Directories
'Tributes to Cousins Confectionery founder Ernest Gibson', *Liverpool Echo*, 21 January 2010
The Story of Irwin's: 50 Years of Unrivalled Grocery Service (1950)

If you enjoyed this book, you may also be interested in…

Merseyside War Years Then & Now

DANIEL K. LONGMAN, COLOUR PHOTOGRAPHY BY TONY SHERRATT

With its strategic shipping ports and factories, the towns and cities dotted along the River Mersey soon became some of Hitler's most heavily targeted sites during the Second World War. Featuring 45 vistas of bomb-damaged suburbia and city centre carnage alongside 45 photographs of the area as it is today, *Merseyside War Years: Then & Now* sensitively documents the changes and developments that have taken place in Merseyside since those dark days of war, demonstrating both architectural progress and Britain's resilience and in the face of adversity.

978 0 7524 6352 0

Liverpool Then & Now

DANIEL K. LONGMAN, COLOUR PHOTOGRAPHY BY PETER GOODBODY

Contrasting forty-five archive images with full-colour modern photographs, *Liverpool Then & Now* compares the fashionable man about town to his modern counterparts, and workers of yesteryear with today's trades-people. Along with some famous landmarks and little-known street scenes, this is a wide-ranging look at the city's colourful history. As well as delighting tourists, it will provide present occupants with a glimpse of how the city used to be, in addition to awakening nostalgic memories for those who used to live or work here.

978 0 7524 5740 6

Liverpool's Children in the 1950s

PAMELA RUSSELL

This book is packed with the experience of schooldays, playtime, holidays, toys, games, clubs and hobbies conjuring up the genuine atmosphere of a bygone era. As the decade progressed, rationing ended and children's pocket money was spent on goodies like Chocstix, Spangles, Wagon Wheels and Fry's Five Boys. Television brought *Bill and Ben*, *The Adventures of Robin Hood* and, for teenagers, *The Six-Five Special*, along with coffee bars and rock 'n' roll. This book opens a window on an exciting period of optimism, when anything seemed possible, described by the children and teenagers who experienced it.

978 0 7524 5901 1

Bloody British History: Liverpool

KEN PYE

This book contains the amazing and dramatic history of Liverpool. Beginning with the mysteries of the Druids and featuring astonishing tales of bloodshed, battles and the Black Death, and horrors from history including Viking assaults, Victorian gangland riots, the mud, blood and bullets of the Western Front and the falling bombs of the Blitz, read it if you dare! With more than 70 illustrations, you'll never look at local history in the same way again!

978 0 7524 6551 7

Visit our website and discover thousands of other History Press books.

www.thehistorypress.co.uk